IMAGES
of America
WARM SPRINGS

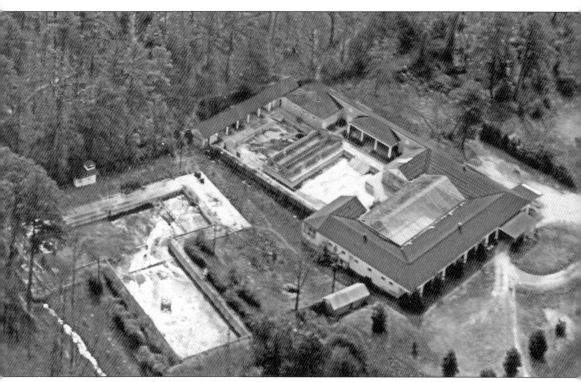

During the 1930s, the largest of Georgia's seven warm springs filled polio treatment pools (right) built by Franklin D. Roosevelt. From there, they filled the famous T-shaped pool with a flow rate so strong that it maintained a temperature of 88 degrees throughout all the pools. There was even a runoff creek (left) of the "T" pool.

On the Cover:
The old Southern Railway depot had seen many visitors during its years in service. It was not uncommon for a few people to gather, waiting on the train. The one event that drew all of the townspeople together was when Franklin D. Roosevelt came to town. After he became president, people would walk for miles to Warm Springs to get a glimpse of this famous American statesman. After all, he was their neighbor living in the Little White House just up the street. A celebration occurred every time he arrived. These were happy times for the community. The most powerful person in the world had come home to the small village of Warm Springs.

IMAGES
of America
WARM SPRINGS

David M. Burke Jr. and Odie A. Burke

Copyright © 2005 by David M. Burke Jr. and Odie A. Burke
ISBN-13 978-0-7385-4199-0

Published by Arcadia Publishing
Charleston SC, Chicago IL, Portsmouth NH, San Francisco CA

Printed in the United States of America

Library of Congress Catalog Card Number: 2005930280

For all general information contact Arcadia Publishing at:
Telephone 843-853-2070
Fax 843-853-0044
E-mail sales@arcadiapublishing.com
For customer service and orders:
Toll-Free 1-888-313-2665

Visit us on the Internet at www.arcadiapublishing.com

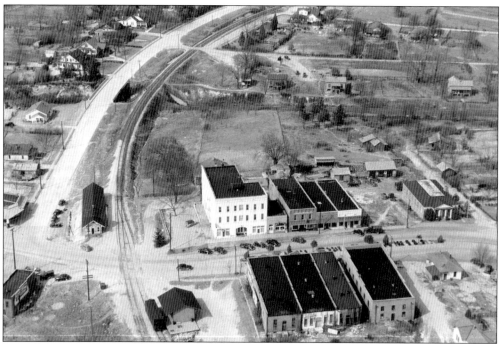

Located in western central Georgia, the village of Warm Springs looks similar today to the way it did in the 1930s when this picture was made. Where the old Southern Railway depot was located, the FDR/Warm Springs Welcome Center stands today. Hotel Warm Springs, the large white building, still serves travelers as a bed and breakfast and has remained a landmark towering over the low-roofed shops that line Main Street. Newer buildings have since been added to accommodate the tourist trade that thrives in Warm Springs.

Contents

Acknowledgments 6

Introduction 7

1. A Unique Geology 9

2. A Rendezvous with Destiny 13

3. A Small Settlement Becomes a Town 17

4. The Meriwether Inn 25

5. The Spirit of Warm Springs 39

6. The Little White House 69

7. Warm Springs and a President 79

8. April 12, 1945: The World Focuses on Warm Springs 111

9. The Waters of Warm Springs Still Flow 117

ACKNOWLEDGMENTS

The authors wish to thank Jean C. Burke, Deborah K. Ardis, Sarah Burke, and Monte Burke as well as Donnie Barnes, David Coplen, Cindy Coplen, and Suzanne Pike for their support and friendship. We also want to thank the following agencies for giving us permission to use their archives as a source of many unpublished images: the Roosevelt Warm Springs Institute for Rehabilitation, with librarian Mike Shadix (www.rooseveltrehab.org); the Georgia Department of Natural Resources; Little White House State Historic Site, Site Manager Frankie Mewborn and Assistant Manager Mary Thrash (www.fdr-littlewhitehouse.org); the Library of Congress; and Sabra McCullar at the FDR/Warm Springs Welcome Center (www.warmspringsga.ws). These agencies and their staff were most accommodating in this project. Although all the sources had many of the same images, each had enough different ones to fill some gaps. Other acquisitions from eBay were used to complete the book.

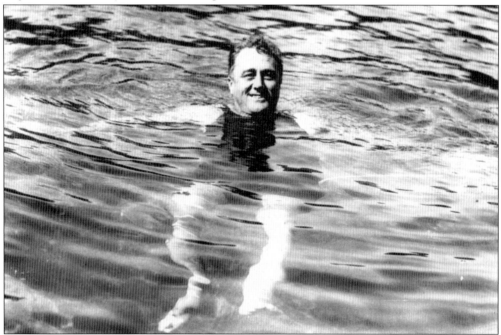

"With him [Roosevelt] everything in Warm Springs is 'great' or 'fine' or 'wonderful.' That is the spirit that has carried him. . . . it is the spirit that is going to restore him . . . for political and financial battles and successes in the years to come." Cleburne Gregory wrote this about FDR for the *Atlanta Journal* in 1924 during Roosevelt's first visit.

INTRODUCTION

If one were to consider the historic places of our vast globe or the Seven Wonders of the World, many names and places come to mind: Jerusalem, London, and Rome are just a few of the cities that have made a mark in the annals of history. Locations such as Gibraltar, the Sahara, or the Alps conjure up thoughts of the events that have occurred there. There are places around the world where time, circumstance, people, and nature all came together at the precise moment when something unique happened. Historians have recorded these places in depth. Warm Springs, Georgia, however, does not come to mind when one contemplates such cities of grandeur, majestic mountain ranges, or sea trading ports. After all, Warm Springs is in the middle of western central Georgia. At first appearance, there does not seem to be anything noteworthy or special about the place. If one were to put together a study of the Warm Springs region, with its varied geology and history, he or she might reach the same conclusion many are now coming to realize. Warm Springs, through natural or man-made circumstances, is a place where the course of history was quietly rewritten.

From the earliest of days in our history, the warm waters that burst forth from Pine Mountain have provided a spirit of healing to all who have used them. By taking a closer look at the little-recorded events around the springs, one would discover the legends of Native Americans using the springs as a source of healing. As Europeans learned of the warm natural baths, the development of taverns and hotels took place, drawing upon the springs' therapeutic qualities as a source of income. In the 20th century, a man stricken by polio would hear of the mysterious healing qualities of the springs and the legends and would seek a cure for his polio within them. Though he would not find a cure, Franklin Roosevelt would become a catalyst from which the springs' natural course would be altered. Along with this change, the course of history would also be altered. As if the springs had a life of their own, they used Roosevelt to become a beacon of hope in the mind of millions.

The "Spirit of Warm Springs" is a whisper or quiet voice that seeks out people. It calls people today. Thousands upon thousands answer the call every year. Whether it is the water they wish to bathe in or to see the area Franklin D. Roosevelt came to live and love, throngs of visitors descend upon the small village at the northern end of Pine Mountain. These two powerful forces have now become entwined in the hearts and minds of a nation. Today the quiet whisper that draws people to Warm Springs is as much alive as it was when FDR or the early settlements of the Native Americans answered their call. When all who have experienced the spirit of Warm Springs leave, they realize that something very special has touched them.

There is enough local history within the many families, communities, and geographical areas around Warm Springs to fill many books with colorful stories of Southern life in rural Georgia. It is possible to write a book about FDR and barely mention Warm Springs. It would be impossible, however, to write a book about Warm Springs without Franklin D. Roosevelt. There are many coffee table books highlighting the life of Roosevelt. In them, there are one or two pictures of Warm Springs. Today one could not today create a picture book without showing the impact

FDR had on Warm Springs and its environs. This book is intended to provide an overview or a general history of the warm springs and the area that has benefited from their source. It is not intended to serve as a biography nor does it cover every aspect of the many facets that make up Warm Springs today. It is our hope that this book will serve to provide a visual image of what FDR came to call "The Spirit of Warm Springs" through the many unpublished images that have been preserved in archives, local homes, and personal collections of those who find Warm Springs special.

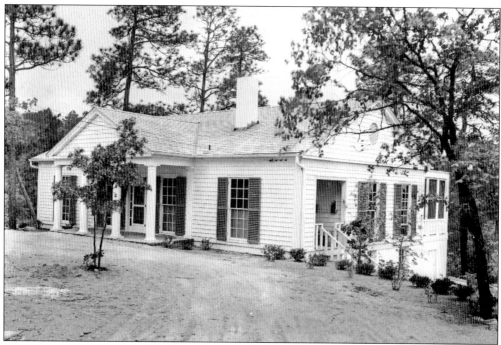

Franklin D. Roosevelt's Little White House, built in 1932, became a memorial to America's only four-time elected president in 1947 as a national shrine.

One

A Unique Geology

*Nobody knows anything about the water, where it comes from and where it goes.
All we know is that out of those hills come all kinds of waters.*

—FDR, 1933

Pine Mountain, old and worn down by millennia, sits in the middle of west central Georgia. On its flank is the Towaliga fault line. Occasionally it moves as the continental plates adjust themselves to pressures deep from underground. For all practical purposes, the fault has gone to sleep forever. The Towaliga has solidified to become a wall of granite. Geological reports state that the rain falling on Pine Mountain takes many paths through the earth. One path runs through the mountain, bursting out as Cold Springs. Another path becomes iron-rich Chalybeate Springs. Not far from there are White Sulphur, Yellow Sulphur, and Black Sulphur Springs. It is the Warm Springs, however, that gained popularity over the course of centuries. There are seven warm springs in the region that stretches from Pine Mountain to Barnesville, Georgia. They are Taylor Spring, Parkman Spring, Brown's Spring, Thundering Spring, Lifsey Spring, Barker Spring, and the biggest of them, Warm Springs. The rainwater flows through cracked Hollis quartzite, above a floor of impermeable Woodland gneiss and below a layer of hardened Manchester schist. The quartz channel cuts between these layers through the earth to about 3,800 feet deep, where the water temperature is raised to about 120 degrees. At the point that the water runs into the solid wall of the Towaliga fault, there is nowhere to go above or below, so pressure forces it back along the path it came. There is an outcropping of fractured quartz at the base of Pine Mountain where the immense pressure of the heated water, mixed with the downward-flowing water, is released. At over 900 gallons per minute, the 88-degree mineralized water created large ponds and streams. The water had been flowing long before recorded time, and it would be only a matter of time before man would come to use them.

This old photograph from a scrapbook shows Pine Mountain sitting in the clouds. At nearly 1,400 feet above sea level, its many scenic views and varied geological features have provided people a destination spot for centuries.

The most pronounced feature of the Greenville Plateau is Pine Mountain. Many different steams of mineralized water flow from it to form ponds as seen in the Pine Mountain Valley. The rocks that create the Warm Springs and numerous other mineral springs are all pre-Cambrian and some of the oldest rocks on earth.

Water exiting Pine Mountain creates many small waterfalls such as Cascade Falls. There are numerous miles along the Pine Mountain Trail system that lead hikers and backpackers to the various falls within FDR State Park.

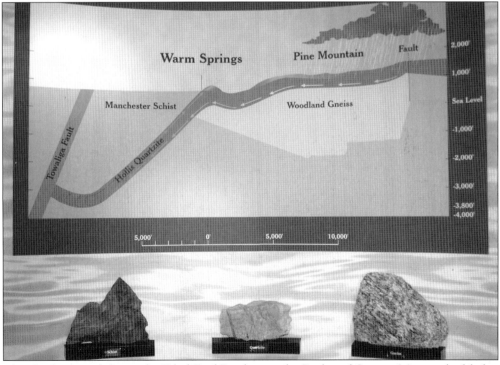

This display on exhibit in the Edsel Ford Pavilion at the Pools and Springs Museum highlights the types of rock that provide the minerals in the Warm Springs. Chief among these elements is magnesium. Combine sulphur with the magnesium and this Epsom-salt-like water provides the swimmer with a soothing experience on the muscles. The high concentrate of bicarbonate provides lift to the swimmer, similar to that of the ocean.

The warm springs formed natural pools or ponds of water before any man-made pools were established. In the dead of winter, the ecosystem could thrive with the warm flowing water, keeping the ground temperature near the edge warm enough to support tender grasses and other vegetation. Tadpoles can be found swimming on the coldest of days, while light wisps of steam rise above the waters, giving the only clue that winter is in full force.

spring, stream, and well waters in and near Warm Springs, Ga.

[ted by W. L. Lamar, except no. 41. Analyses given in parts per million]

No.		Temperature (°F.)	Total dissolved solids	Silica (SiO₂)	Iron (Fe)	Calcium (Ca)	Magnesium (Mg)	Sodium (Na)	Potassium (K)	Bicarbonate (HCO₃)	Sulphate (SO₄)	Chloride (Cl)	Fluoride (F)	Nitrate (NO₃)	Total hardness as CaCO₃
	WARM SPRINGS														
1	Warm Springs:	88.0	121	23	0.01	21	12	1.6	3.6	118	7.3	1.8	0.1	0.10	102
	East source	87.7	123	25	.01	21	12	2.1	3.5	118	7.9	1.8	.1	.15	102
		87.4	117	21	.02	20	11	1.7	3.5	114	7.0	1.8	.1	.15	95
	West source	87.1	120	24	.01	20	11	2.1	3.4	115	7.4	1.8	.1	.15	95
2	Parkman Spring	76.6	114	21	.03	19	11	2.6	2.5	111	5.1	2.0	0	.05	93
3	Brown's Spring	69.0	144	25	.03	27	10	2.8	4.3	144	4.9	1.8	0	0	108
		68.1	144	28	.03	27	11	3.1	4.4	143	5.1	1.8	0	.06	113
4	Thundering Spring	74.2	66	14	.03	9.9	5.7	2.1	2.0	61	3.0	1.8	0	0	48
		73.9	67	16	.02	10	5.9	2.3	1.8	63	3.0	1.8	0	.05	49
4A	Small spring tributary to Thundering Spring	72.6								84	3	2		0	66
		71.9	83	18	.02	14	7.6	2.4	2.4	82	4.0	1.8	0	.05	66
5	Barker Spring	73.4	107	16	.02	19	11	2.4	3.4	114	4.4	1.5	0	0	93
		74.2	112	23	.01	19	11	2.8	3.0	116	4.3	1.6	0	0	93
6	Lifsey Spring	78.5	141	30	.01	23	11	7.4	3.2	137	5.6	1.8	.1	.15	103
7	Taylor Spring	74.8	105	20	.01	18	10	2.9	1.9	111	4.1	1.6	0	0	86
	COLD SPRINGS														
8	Blue Spring	64.5	43	12	.04	5.0	2.9	2.1	1.1	31	1.9	1.8	0	.05	24
		64.4	45	14	.01	5.5	2.9	1.9	1.5	32	1.3	2.0	0	.06	26
9	Trammel's Spring	62.2	14	7.6	.02	.2	.3	1.7	.5	3.0	1.2	1.6	0	0	1.7
10	Cold Spring	63.4–65.0	14	7.3	.02	.4	.3	1.1	.2	2.0	1.1	1.4	0	.05	2.2
		63.0–64.2	14	7.9	.02	.5	.3	1.0	.4	2.6	.7	1.5	0	.05	2.5
11	North Spring	66.1	18	9.4	.01	.7	.4	1.4	.5	4.0	1.4	1.4	0	0	3.4
		65.6								3.5		1.4			
12	South Spring No. 1	64.3	17	9.0	.01	.6	.3	1.4	.7	4.4	.8	1.5	0	.06	2.7
		63.9	14	6.8	.02	.3	.4	1.5	.2	3.0	1.2	1.4	0	.43	2.4
13	White Sulphur Spring	62.5	16	6.8	.01	.7	.3	1.2	.4	2.0	2.2	1.5	0	.34	3.0
14	Black Sulphur Spring	62.2	141	46	.02	17	3.2	16	2.0	100	6.0	2.1	.3	0	56
15	Red Sulphur Spring	63.8								97	6	2			
16	Chalybeate Spring	66.4								96	6	2			
17	Kings Gap Spring	62.6	15	8.0	.01	.2	.3	1.5	.4	2.0	1.1	1.8	.0	.0	1.7
18	Pine Mountain Spring	59.0								2.0	1				
19	Oak Mountain Spring	62.8	109	38	8.0	8.6	5.4	8.3	3.4	58	13	2.4	.0	.05	44
20	Chalybeate Spring No. 1	65.2	126	41	3.4	12	5.3	8.5	3.3	81	10	1.8	.1	.05	52
21	Chalybeate Spring No. 2	64.7	130	45	2.8	12	6.3	8.3	3.4	81	9.8	1.9	.0	.08	56
22	Chalybeate Spring No. 3	65.4								83	10	2			
		65.0								82	10	2			

The geological survey of 1937 provided many answers to the questions of why the warm springs exist. This chart shows the mineral content found within the seven warm springs as well as the Cold Springs just over a mile away.

Two

A Rendezvous with Destiny

Incidentally, we lack a sense of humor and of proportion if we forget that not so very long ago we were immigrants ourselves.

—FDR

As Europeans and Native Americans met, conflicts developed, and many skirmishes ensued in the New World territories. The Creek tribe occupied the area of western Georgia, and legend states that enemies who sought the warm springs were granted safe passage through the lands. Warriors wounded from battles used the springs for its healing qualities. A kindred spirit of peace was felt among the adversaries, thus giving birth to what would become known decades later as "The Spirit of Warm Springs." Only general references support these legends. There is neither archeological evidence nor are there any eyewitness accounts of Native Americans using the warm springs. The conflict between Native Americans and settlers would continue as the colonies were formed. This clash would ultimately lead to the Native Americans being kicked out of the states of the young nation. The Treaty of 1825, signed at Indian Springs by Chief William McIntosh, gave Georgians the Indian lands as they were to be sent west. The Trail of Tears that began in Georgia ended in the western territories of Oklahoma.

The vacuum left from the departing Creeks was quickly filled with settlers seeking a new life. The land covered by the treaty was disposed of by state lottery, and in 1827, five new counties were created. One of them was Meriwether County named for Gen. David Meriwether of Revolutionary War fame. With the fate of the Native Americans decided, new landowners settled on the slopes of Pine Mountain. As fate would have it, the first owners of Warm Springs were orphans.

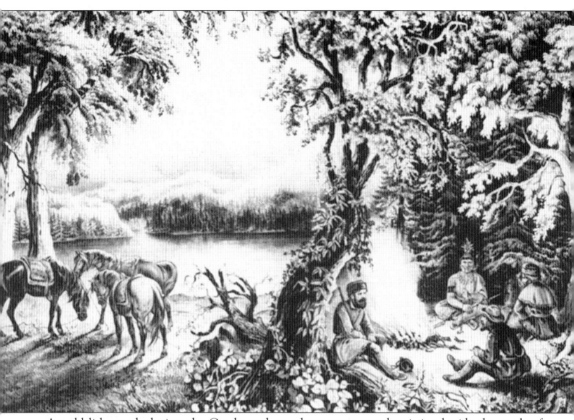

An old lithograph depicts the Creeks and an adventurous traveler sitting beside the pools of water. This image illustrates the legends passed down through time that those seeking passage to the warm springs were given sanctuary. (Courtesy Library of Congress.)

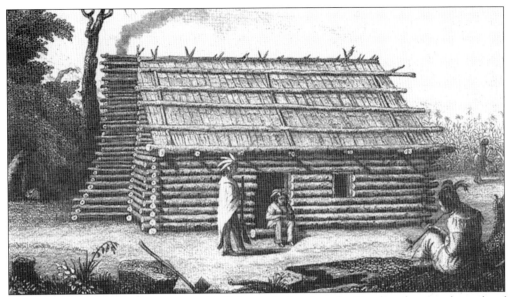

European influence can be seen in this lithograph showing the Creeks adopting the style of housing used by the new settlers. Both sides learned from each other, and both sides wanted peace. But neither side could be assimilated into the other's culture as the growing population of Georgians demanded more land. (Courtesy Library of Congress.)

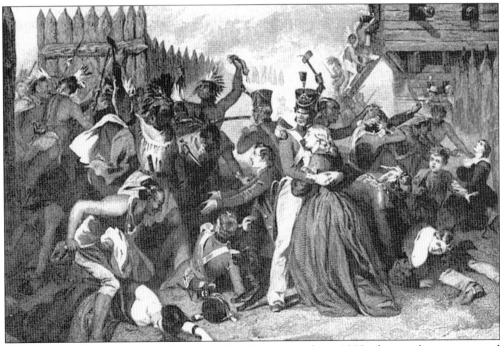

One of the earliest treaties with the Creek tribe was made in 1805 where military posts and horse paths through Native American country were allowed. By 1811, a tavern was established near Warm Springs on one of the post roads. The Creeks desperately fought for the lands they kept losing, and by 1825, only 7,000 or 8,000 Creek warriors remained in the lands in the vicinity of the Warm Springs. (Courtesy Library of Congress.)

Many treaties were signed and broken both by the newcomers and the Native Americans. Following the Treaty of 1805, treaties were made with the Creeks every few years, and with the fighting that followed the Treaty of 1825, the Native Americans' fate was sealed. The land was ceded to the federal government. Chief McIntosh, who signed the treaty, was massacred at his plantation home, and the Native Americans were sent west in the Trail of Tears. (Courtesy Library of Congress.)

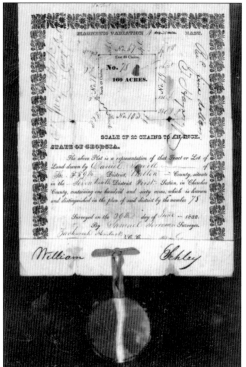

This is one of the land lottery certificates issued during the state land lottery. The lot on which the Warm Springs are located was given to one of the "fortunate drawers" who was Barton S. Park, an orphan from Putnam County, and a group of orphans from neighboring Baldwin County.

Three

A Small Settlement Becomes a Town

Because after all, Warm Springs, to be successful in the future, has got to make some progress every year—all through the years.

—FDR on the growth of Warm Springs

When Meriwether County was created in 1827, settlement began immediately. Warm Springs was incorporated with three commissioners. David C. Rose, Joseph Andrews, and Charles Harris were to "oversee the well being of its inhabitants and visitors." Rose acquired the warm springs in 1832 and began development. He constructed larger buildings that were offered as lodging and could sufficiently handle 200 guests. In 1844, ownership of the resort changed hands to Col. Seymour Bonner. He further developed the property, enticing more people to build their summer homes at the springs. With improved lodging, more visitors sought out the cool breezes of Pine Mountain. Hotel registers dating back to the 1840s list the names of Henry Clay, John C. Calhoun, and other prominent statesmen of that period who lodged at Warm Springs.

In 1848, John L. Mustian acquired the springs. Having a vested interest in the stagecoach line, which provided travelers transportation to the springs that up to that time had to rely upon their on methods of travel, he further developed the property to accommodate 300 guests. But in 1869, the hotel burned. The chore of rebuilding fell upon his grandson, Charles Davis, who in 1874 took over the property. He oversaw the building of a larger hotel, added more cottages, and built six masonry chambers, each 10-by-10 feet for bathing.

Around this same time, brothers Cyprian and Benjamin Bulloch founded the town of Bullochville with their cousin, W. T. Bussey, in 1887.

In 1889, the hotel was again destroyed by fire. With nearby Bullochville located on the Georgia Midland Railroad line, later to become part of the Southern Railroad, visitors continued to seek the Warm Springs and plans for an even larger hotel were designed. The town of Bullochville grew. Entrepreneurs and civic-minded people developed businesses, churches, and schools. Also from the Cold Springs, one of the nation's oldest fish hatcheries came into being.

David Rose oversaw the building of bathhouses near the springs and subdivided the land into lots. People from Columbus built homes on their lots, and these "cottagers" were granted full use of the baths. The largest bath was 10-by-12 feet and the other was a 4-by-12-foot bath. The water depth was nearly 4 feet. Locally there was a doctor's office, a confectionery, blacksmith, and other elements that provided a sense of civilization.

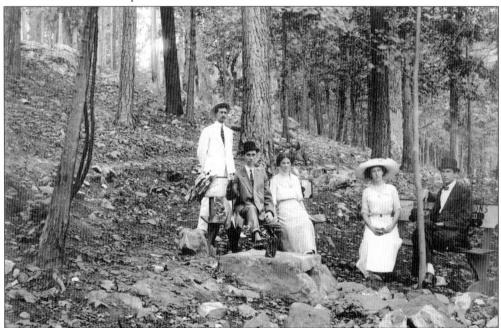

More and more visitors sought the soothing qualities of Warm Springs, and until the Georgia Midland Railroad was established, horseback and buggy were the only modes of transportation. When John L. Mustian created a larger resort to meet the increased growth, he encouraged people from Columbus to build summer cottages in the area.

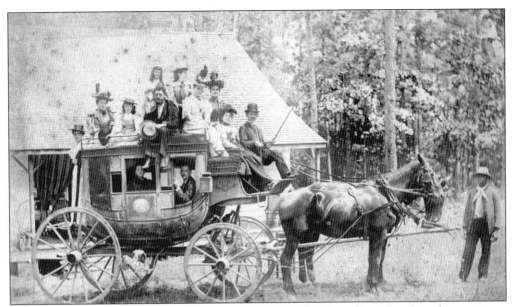

The Tally-Ho, a Concorde model stagecoach, was owned and used by Mustian to bring visitors from Columbus to Warm Springs and other resorts nearby. With the new Georgia Midland established, visitors could ride the train to Warm Springs and then catch the stage to the hotel and springs.

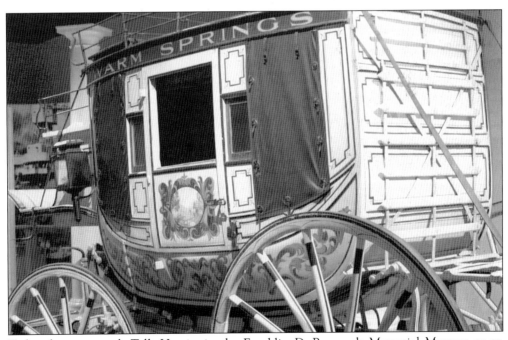

Today the stagecoach Tally-Ho sits in the Franklin D. Roosevelt Memorial Museum as an exhibit. It has been stabilized and restored to its original condition by the Georgia Department of Natural Resources.

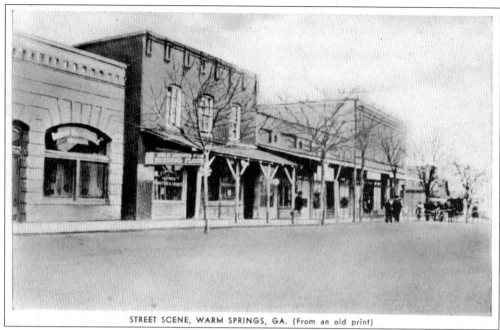

STREET SCENE, WARM SPRINGS, GA. (From an old print)

Fate stepped in when the resort hotel burned down in 1889. The newly founded town of Bullochville was flourishing. Businesses were able to provide construction materials for a newer and larger hotel, and a bank was established, as seen in this postcard of a street scene in Warm Springs. Note the buggy far right of town.

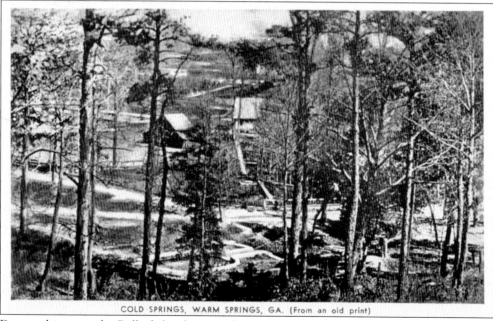

COLD SPRINGS, WARM SPRINGS, GA. (From an old print)

During this time, the Bulloch brothers purchased Cold Springs, just over a mile from Warm Springs, in 1891. Located on the plantation property were some old wooden buildings that were moved closer to the depot, on the east side of the tracks, in Bullochville.

This is the home of Cyprian Bulloch Jr., located near the Cold Springs. The springs provided fresh water to the town of Bullochville because of the immense pressure from the springs. This water pressure filled a tank nearly a quarter of a mile away, behind his brother Benjamin F. Bulloch's house, that was used as a method of distribution to townspeople.

Sawmills in the Warm Springs area were constantly in use with the abundant pines and plentiful hardwoods available for milling. With plans for a new hotel, the Meriwether Inn, on the drawing board, the mills would keep busy for years as a community of "cottagers" built their summer homes around the resort and as other families were moving into nearby Bullochville.

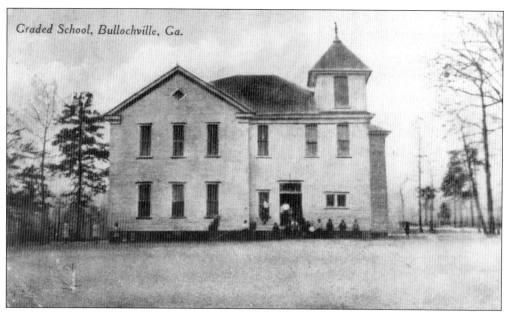

During this period of growth, there were many concerns about the future of Bullochville. New families moving into the area wanted stability. This issue was addressed in part by the building of the Graded School. This provided sense of permanence, as parents knew that their children would receive an education.

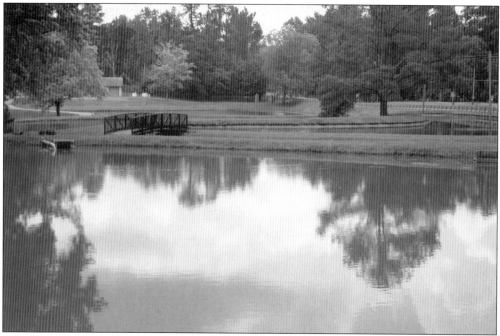

A law passed by Congress in 1898 established the National Fish Hatchery to be built by the federal government on lands donated by Cyprian Bulloch Jr. The Cold Springs provided enough cool water at an average of 65 degrees to provide ample supply for the hatcheries and the town. One-third was allotted to the town of Bullochville. (The town of Warm Springs today still draws upon the Cold Springs for its water supply.)

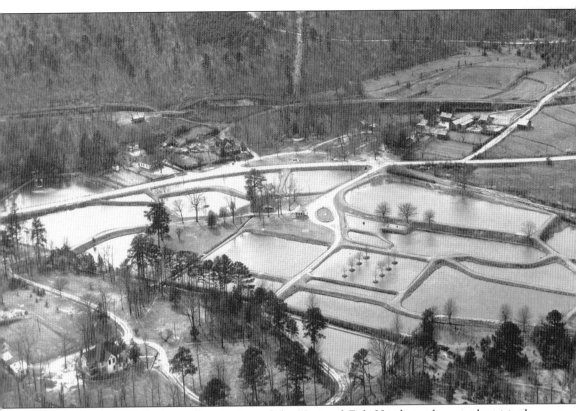

This aerial photograph shows the expanse of the National Fish Hatchery that can be visited today with its walking trails and aquarium. Although not pictured, the town of Bullochville (today Warm Springs) is located just to the left of the image.

When the Southern Railway took over the Georgia Midland lines, the company saw immediate benefits in advertising Warm Springs as a destination. Brochures, like this one pictured, were placed in depots and hotels across the South advertising weekend and Sunday round-trips and summer tourist tickets.

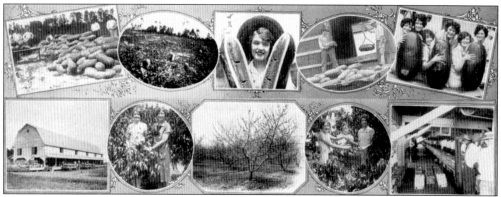

Southern Railway brochures included photographs of Warm Springs's farms with fresh watermelons, milk and butter from dairy farms, and orchards full of peaches. These and other sundries offered would alleviate any concerns the traveler might have for comfort foods. With the promise of the new Meriwether Inn on the horizon, Warm Springs was sure to flourish, and the Southern Railway wanted to be a part of its success.

Four

The Meriwether Inn

Many of the rooms have their own private balconies, while broad verandas furnish ample sitting rooms for all our guests.

—Meriwether Inn travel brochure

Charles Davis built the Meriwether Inn in 1893. This Victorian-styled three-story inn boasted of electric lighting, sanitary sewage, and 120 rooms. Combined with the adjoining cottages, the resort could accommodate 250 guests. Travel literature from the era states the resort was gaining favor as "a gathering place for politicians and public men of prominence." One enhancement was the addition of two new 15-by-45-foot enclosed pools, one for men and one for women.

For the next two decades, the Meriwether Inn Resort grew to include a huge dance floor with Mike Rose's Italian Orchestra often performing, Brunswick bowling alleys, a baseball diamond, and athletic field. Numerous private 4-by-8-foot pools and a large 50-by-150-foot open pool were added, attesting to the flow rate of the springs. By the 1900s, travel brochures were advertising the curative qualities of the springs that "Makes you well if you're ailing: keeps you well if you're not. Cures Rheumatism, Dyspepsia, Stomach Troubles, Nervous Disorders, Liver and Kidney trouble; dead shot for Insomnia. The best water you ever drank."

As the automobile replaced the train, travelers sought out different destinations not offered by the rail lines, and thus the Meriwether Inn fell into a state of decline. After Davis's death, the now rundown property was bequeathed to his niece, Georgia Mustian Wilkins. In 1919, newspaperman Tom Loyless and financier George Foster Peabody leased the property with the hope of restoring the resort to its former glory. Over the course of three summers, they observed a young polio victim, Louis Joseph, regain the use of his legs from swimming the springs. In 1921, Peabody made it a point to tell a friend of his who was stricken with polio, Franklin D. Roosevelt.

By 1924, the towns of Warm Springs and Bullochville merged as one town under the name of Warm Springs, Georgia.

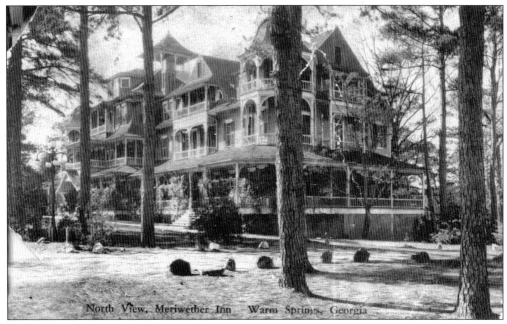

The newly built Meriwether Inn, with its three stories and 120 rooms, was described as a rambling green, yellow, and white Victorian. Numerous turrets, spacious porches, balconies, and verandas gave this inn an almost eccentric appearance sitting on the hill above the pools and springs.

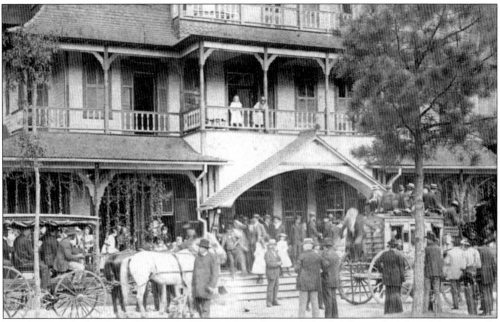

People came by horse and buggy and by stage to the newly built Meriwether Inn. Many people found Warm Springs so charming they made plans to move there permanently. With the Graded School, shops, churches, and the railroad in nearby Bullochville, people felt that Warm Springs was a good place to settle down and raise their families. Even today, many descendants of these one-time tourists still live in the region.

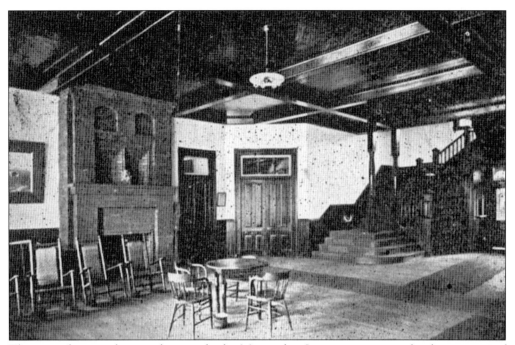

This rare photograph was taken inside the Meriwether Inn in preparation for the invasion of guests eager to try the baths, carriage rides, and accommodations in what newspapers called "The most delightful summer resort in Dixie, unsurpassed for attractiveness."

During the "Gay Nineties," Warm Springs was a place where romance thrived as couples chose the Meriwether Inn as their weekend vacation spot away from the busy atmosphere of city life in nearby Columbus and Atlanta.

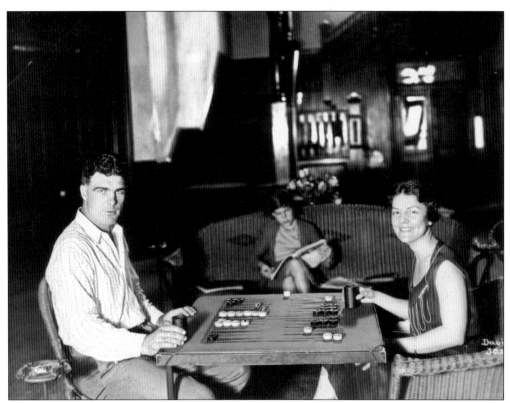

This couple enjoys a game of backgammon in one of the many parlors set aside for card and board games. Davis planned the resort well with its myriad of activities designed to entertain the young and old.

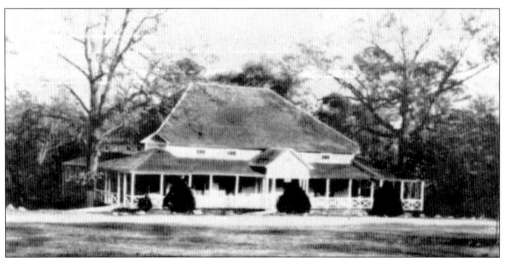

The Pavilion across from the inn boasted of a perfect 70-by-90-foot dancing floor, making this a principal feature of its social life. On Wednesday and Saturday nights, hundreds of young people from nearby towns came to dance to the music of Mike Rose's Italian Orchestra. Travel literature stated that Warm Springs offered one of the best ballrooms of any Southern resort hotel.

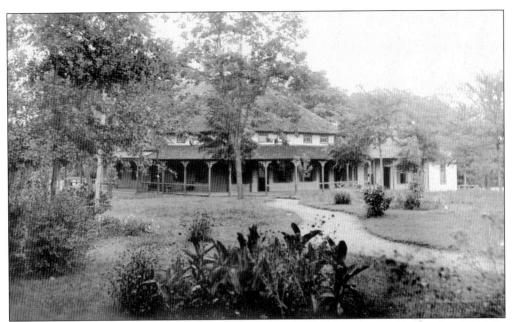

A bowling alley built by Brunswick Lanes was a big draw for visitors who wanted to fill their evenings at the lanes. Situated beside the bowling alley was the post office. Mail arrived from the depot by stage where it was delivered to vacationers. Outgoing postcards and other correspondence was then bagged and loaded on the stage that returned to the depot and awaited the next mail car.

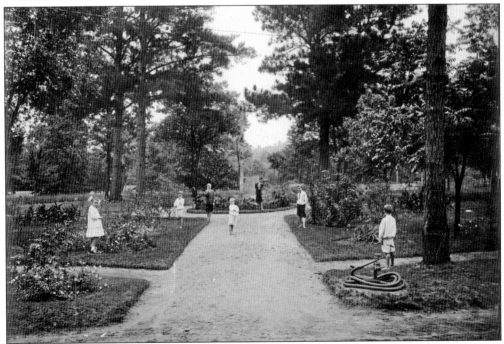

The hotel park provided an ideal playground for children. There were many gardens, a baseball diamond, fountains, and many shaded areas to frolic in. All of this, in addition to one of the smaller pools for kids (called the "little pool"), made it a children's paradise.

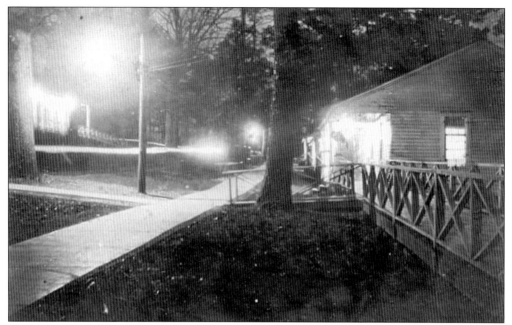

To the travelers who arrived in Warm Springs after dark, a glow of light from the hillside not far from the depot invited them to an evening of comfort. As the Tally-Ho pulled up before the inn, porch-lit cottages and sounds of singing and laughter filled the air. This is the type of atmosphere guests were treated to, and it equaled that of any mountain resort in the Eastern States.

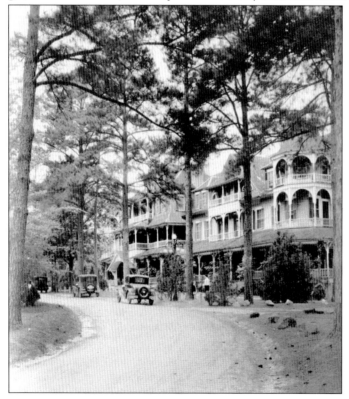

The Meriwether Inn in its heyday rivaled that of any found in the Berkshires, Adirondacks, or Catskills with its wide verandas covered with flowering vines, porch chairs, and a huge dining room.

Warm 88-degree water gushes at over 900 gallons per minute from the hillside and is channeled through piping to fill the pools. The high-flow rate kept the water an even temperature throughout. Even in winter months, during the off-season, the pools could be enjoyed in comfort.

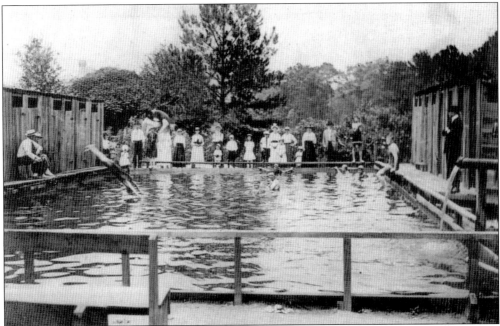

Shutter speeds on cameras at the turn of the century could not keep up with the lively action going on in this picture. One diver is performing a flip in mid-air with another diving head-first before a group of spectators. Notice one of the fill pipes used to keep this smaller pool at an 88-degree temperature.

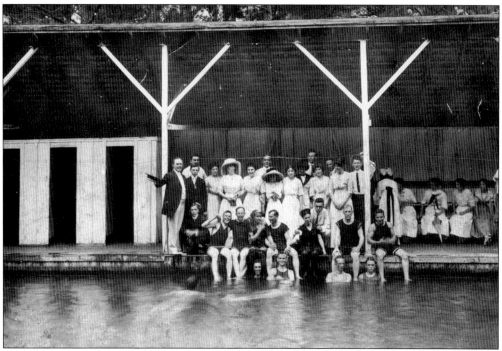

Bathers take a moment and pose for the camera in this group shot at the large 150-foot Open Pool.

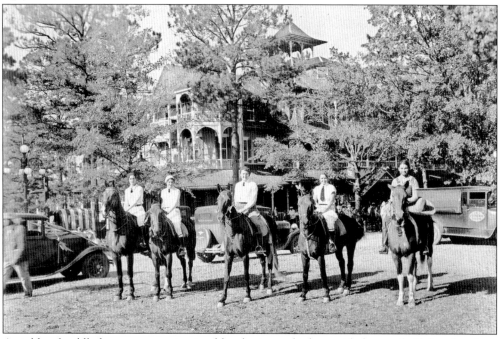

A stable of saddle horses was maintained by the inn, which provided many bridal paths along the base of Pine Mountain. The more adventurous in spirit would ride the trails leading to the "Wolf's Den," a rock outcropping near Cascade Branch, and visit one of the many waterfalls the mountain offered.

"Until the advent of the automobile, guests of Warm Springs were driven in state in a deluxe stage coach over a six-mile scenic route from the railroad station to the inn, although the station was but a half mile away by direct route," states a 1940 Georgia Warm Springs Foundation Annual Report recalling the resort era.

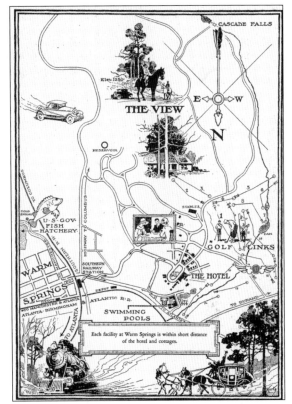

Here the Meriwether Inn stands in all her glory, inviting guests to the refreshing pine-scented air, warm buoyant waters for swimming, and cool elevations free from mosquitoes, malaria, and yellow fever.

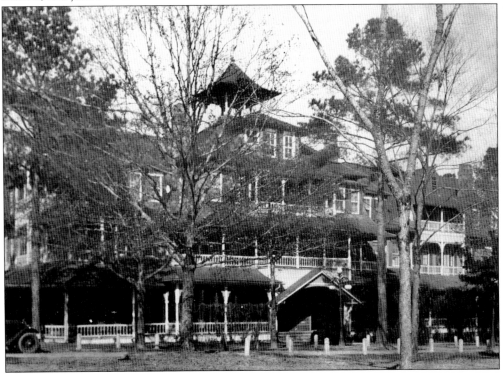

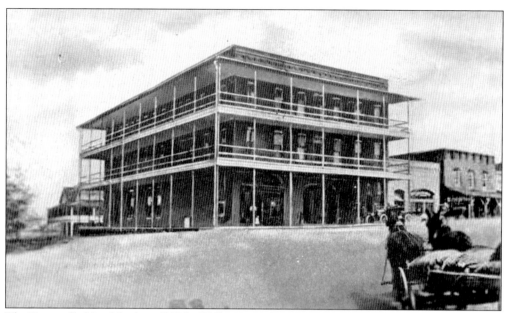

The Tuscawilla Hotel, built in 1907 by Will Butts and named for his daughter, saw occupancy filled nearly every weekend. People arriving by train who could not afford the lifestyle of the Meriwether Inn chose the Tuscawilla as an affordable option. Built directly behind the hotel, a two-story building called Huff House provided accommodations for the overflow from the Tuscawilla.

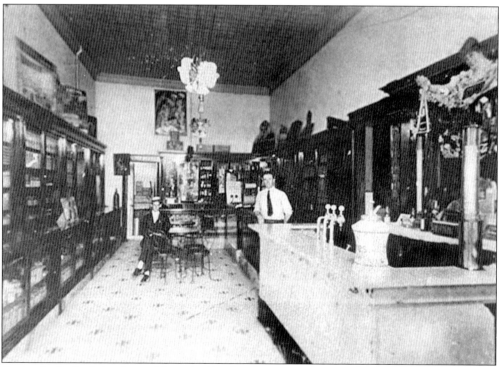

Benjamin Bulloch is pictured here inside the pharmacy that was located in the Tuscawilla. Today this is the location of the Tuscawilla Ice Cream Shop in Hotel Warm Springs.

In 1911, Davis leased the Meriwether Inn resort to Thomas B. Slade. The original letters show that there was an option to buy, but it is not known why Slade never became the owner. It is speculated that because of the automobile becoming commonplace, visitors were seeking different destinations not along the railroad lines.

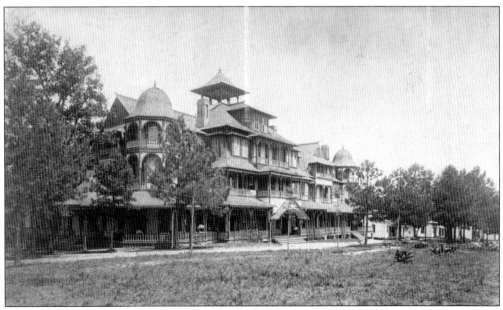

In an attempt to lure travelers back to the Meriwether Inn, many new features were added or enhanced upon. Touting the curative powers of the springs, the story of the Creek Indians bringing their wounded warriors to bathe in the springs was renewed. The mineralized waters seemed to be the only hope to restore the now-waning visitation.

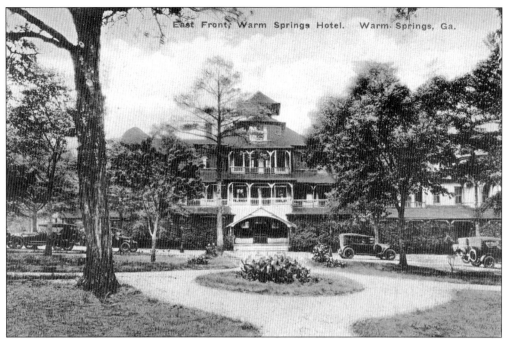

This early-20th-century postcard shows automobiles parked at the Meriwether Inn. It does not show that overall tourism was declining.

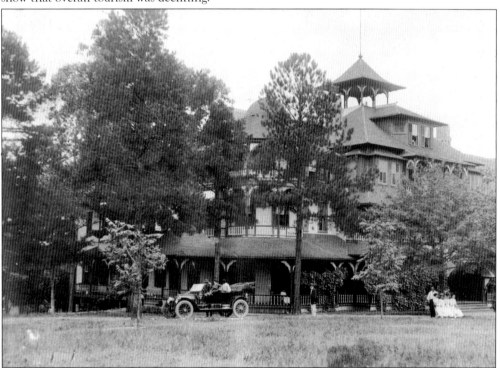

The upkeep of the resort was, by the early 1900s, costing more as revenues dropped. Charles Davis was now back in control of the property, but his health was failing. His niece, Georgia Mustian Wilkins, began to take an interest in the family property.

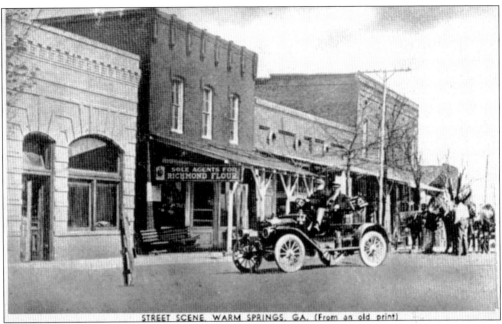

STREET SCENE, WARM SPRINGS, GA. (From an old print)

In the early 1900s, downtown Warm Springs, Georgia, capitalized on the booming tourist trade. Farmers could bring their goods to town to sell to the restaurants, and a hardware store supplied various dry goods. The Bulloch brothers were enjoying prosperous years operating Bulloch Bussey and Company, which built several mercantile stores, the bank, a cotton gin, a government distillery, a flour mill, and a casket company.

WARM SPRINGS, GA. (From an old print)

These business ventures of Bulloch Bussey and Company created jobs, and families settling in Warm Springs joined the workforce. As homes were built, so were churches and schools. The stability created during the boom years helped to insure that Warm Springs would survive the lean years. The industries created in and around Warm Springs and other towns nearby provided employment for the growing community.

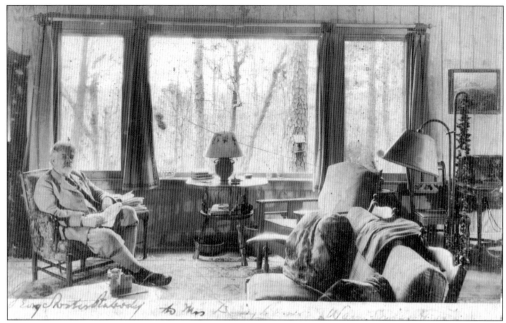

When Charles Davis died, he bequeathed his Warm Springs resort to his niece, Georgia Wilkins. The property had been in the family since the mid-1800s and had been through many transformations. In 1919, she leased the Meriwether Inn, its cottages, and the Warm Springs to Tom W. Loyless and George Foster Peabody, who hoped to transform it to its former glory. This image shows Peabody sitting in his cottage near the Meriwether Inn.

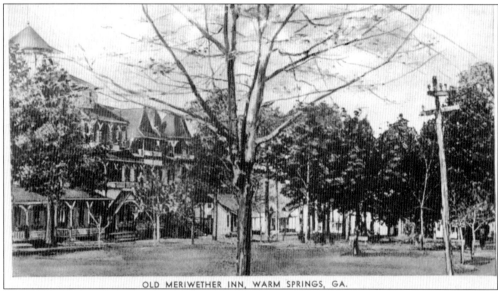

OLD MERIWETHER INN, WARM SPRINGS, GA.

The elements and termites had taken their toll on the 40-year-old Meriwether Inn, constructed with untreated lumber. Restoring the resort would prove to be a costly and difficult if not an impossible task for Peabody and Loyless. During this time, Louis Joseph, a sufferer of polio from nearby Columbus, spent three summers using the pools to practice walking. Soon, he no longer needed crutches. This caught the attention of the proprietors, and they made plans to tell Franklin D. Roosevelt, who also had polio and was wealthy.

Five

THE SPIRIT OF WARM SPRINGS

*Newcomers do not quite understand until they have been here for a week or two—
but it gets them all—the old spirit of Warm Springs.*

—FDR, 1935

On October 3, 1924, the Southern pulled into the depot at Warm Springs. On board, Franklin and Eleanor Roosevelt cautiously waited for Tom Loyless to greet them in the foreign environment far from New York. FDR hadn't walked in three years. Polio had virtually ended his political career. Now he was in Georgia on the off chance that he could someday walk again. Whoever it was that lifted him from the train that day did not realize that he was carrying on his shoulders the one who would complete the transformation of Warm Springs. Nor could he have imagined that he was toting the future president of the United States into an old automobile for transport to a dilapidated cottage.

Upon his first swim in the pools the next day and for the next few weeks thereafter, Roosevelt's life changed. Roosevelt would go on to purchase the resort and Warm Springs using two-thirds of his personal fortune. He would create the Georgia Warm Springs Foundation for polio patients. FDR would also drive the countryside, meet people, and gain an understanding of their problems. He observed the lack of education, the high cost of electric power, and the effects of the Great Depression years before it hit the nation as a whole.

Warm Springs had a profound effect on FDR. He received an education, one that he could not have earned had he remained in New York. Always expressing confidence, he spoke about the spirit of Warm Springs and of a bright future in the town. In the spring of 1932, FDR returned to oversee the construction of his new cottage on Pine Mountain. He had decided to run for president, and he wanted to share this news with his most ardent supporters and those who loved him the most.

Sitting beside the pool in October 1924, Franklin D. Roosevelt expressed the enthusiasm he experienced in Warm Springs. In an interview, Roosevelt said that for the first time in three years, he was able to move his leg. He allowed photographs to be taken of him swimming and relaxing. When published, Cleburne Gregory's article stated, "Franklin D. Roosevelt . . . is literally swimming himself back to health and strength at Warm Springs, Ga."

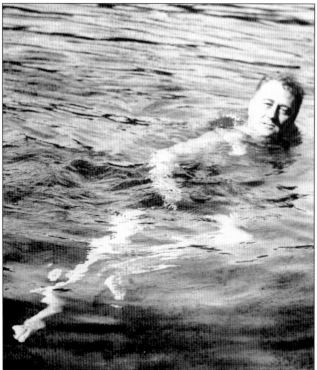

The *Atlanta Journal* Sunday magazine on October 26, 1924, read, "The distinguished visitor has the large swimming pool all to himself for two hours or more each day. He swims, dives, uses the swinging rings and horizontal bar over the water, and finally crawls out on the concrete pier for a sunbath that lasts another hour. Then he dresses, has lunch, rests a bit on a delightfully shady porch, and spends the afternoon driving over the surrounding country, in which he is intensely interested."

In a series of letters, Roosevelt wrote home reassuring his mother that he was doing well: "Dearest Mama, . . . I spent over an hour in the pool this a.m., and it is really wonderful and will I think do a great good, though the Dr. says it takes three weeks to show the effects. Everyone is most kind and this afternoon Mr. Loyless has taken us for a motor trip through the surrounding country—many peach orchards but also a good deal of neglect and poverty. FDR."

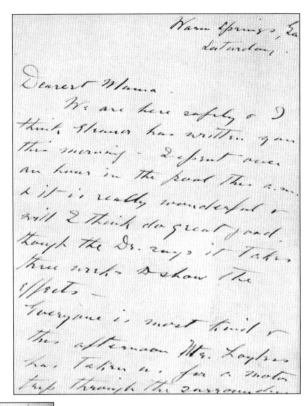

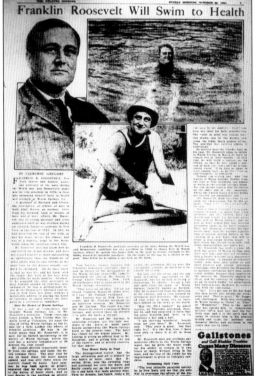

The poolside interview, syndicated nationally, drew unwanted attention. His life and the fate of Warm Springs was about to change forever as polio sufferers across the country made plans to meet Roosevelt in Georgia. He made light of it while writing editorials for the *Macon Telegraph* in April 1925. "There I was, large as life, living proof that Warm Springs, Georgia, had cured me of 57 different varieties of ailments."

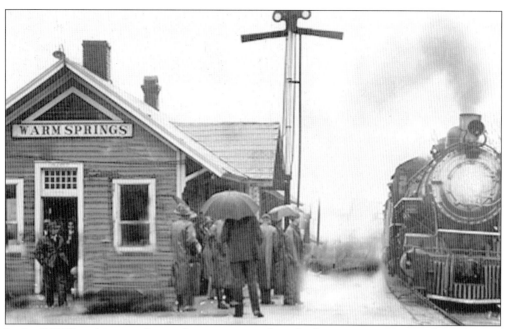

In April 1925, on his second visit, there were a number of polio patients waiting on him who had heard about his "cure" on his previous visit. He wanted to spend time alone fishing, swimming, and making plans to improve the resort with Loyless and Peabody. This intrusion, however, pushed him to helping other polio sufferers, as there wasn't a doctor, and he took on the role for which he was fondly called "Doc" Roosevelt.

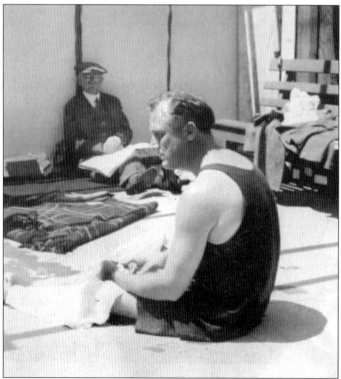

Excited over the therapeutic qualities he discovered, FDR wrote home: "Dearest Mama, The heavenly weather here continues, we have not had a single rainy day since coming, and I spend my full two hours at the pool every morning. . . . I feel that there is a great 'cure' for infantile paralysis and kindred diseases could well be established here. . . . Your devoted son, FDR."

Roosevelt often reminisced about the first polio patients who sought out his help during his early visits in Warm Springs: "One day Mr. Loyless . . . and some of us were sitting around when a messenger came up the hill to Mr. Loyless and said, 'Two people have been carried off the train down at the station. What shall we do with them? Neither of them can walk.' And then I undertook to be doctor and physiotherapist. . . . I taught them all at least to play around in the water."

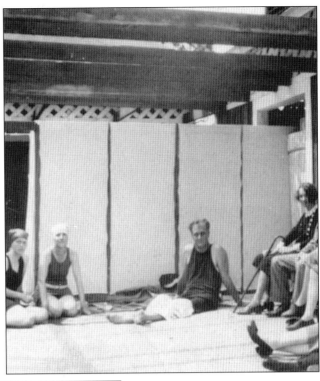

Polio patients were not allowed to ride the train with other passengers in 1925. Fred Botts, traveling to Warm Springs, rode in the baggage car from Pittsburgh inside a wooden cage built by his brother. Upon arrival, FDR taught this young man to swim. He was so skinny that it was feared the power of the springs would pull him through the drain.

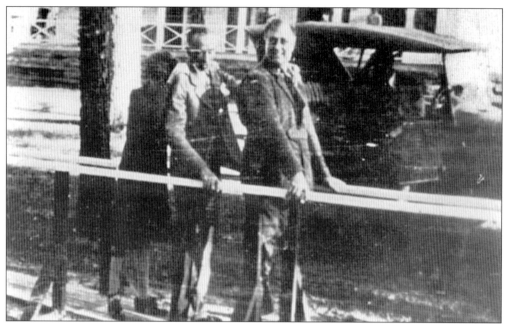

Franklin Roosevelt and Fred Botts became lifelong friends who could depend upon each other. Here they are seen on the walking board practicing their skills together during a therapy session. Botts would later become the registrar of the Georgia Warm Springs Foundation. At any time, he could call the president and receive his attention regarding matters in Warm Springs.

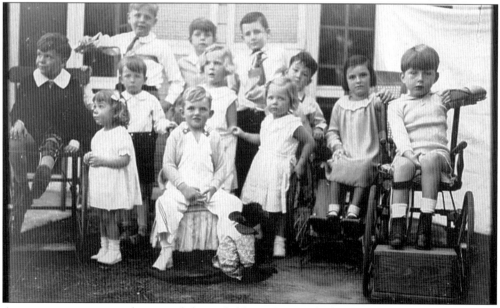

As more patients arrived, most of them children, Roosevelt developed muscle-testing charts and established exercise routines in the pools. The youngest patients began calling FDR "Doc" Roosevelt, while the older children called him "Rosey." The patients used one of the smaller pools, and the water flowed from it in the larger public pool. Many thought that polio spread through water, and there was growing concern among the resort patrons who feared catching the disease.

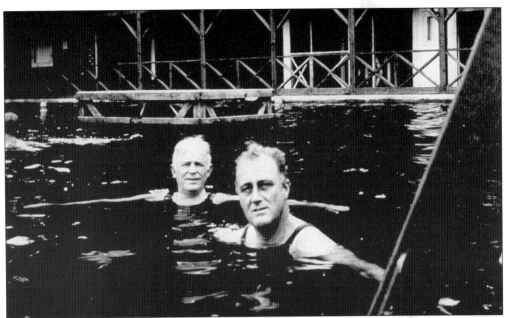

Roosevelt saw potential in the property as a combined recreational and health resort that would use the warm springs as a source of income and healing. He spent much of 1925 contemplating this, wanting to develop a resort equaling that of Pinehurst in North Carolina. Fred Botts wrote, "Mr. Roosevelt, having gathered us around him in the general round table discussion, deftly made inference as to what the future might hold for us."

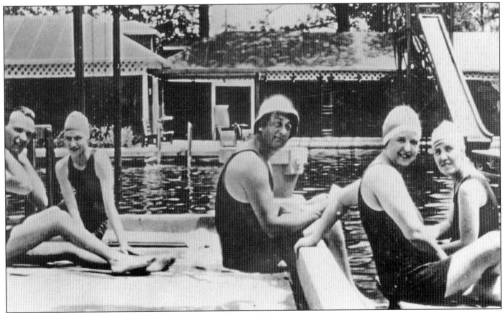

In 1926, the large pool was redesigned into the shape of a T, Tom Loyless passed away, and Peabody discussed selling the resort. Roosevelt built himself a cottage and began buying land nearby for a farm. While on this spending spree, his law partner, Basil O'Connor, drew up papers to purchase the resort for $195,000, two-thirds of Roosevelt's personal wealth. Roosevelt bought some 1,200 acres, which included old cottages, the Meriwether Inn, and the warm springs as its centerpiece.

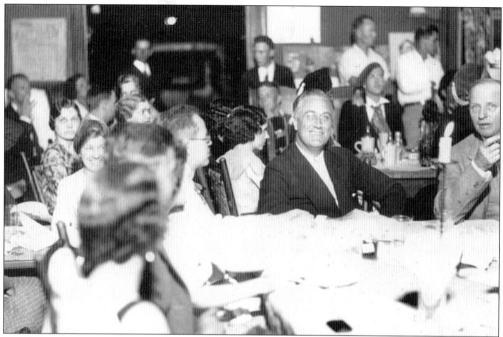

In a letter dated March 27, 1927, Roosevelt wrote to his mother about the transaction. "I had a nice visit from Chas. Peabody and it looks as if I had bought Warm Springs." He now began concentrating on organizing the Georgia Warm Springs Foundation. FDR, with his new friends and patients, is shown celebrating in the dining room of the Meriwether Inn. The presence of the "polios" dining in the same room, however, made paying guests feel uncomfortable.

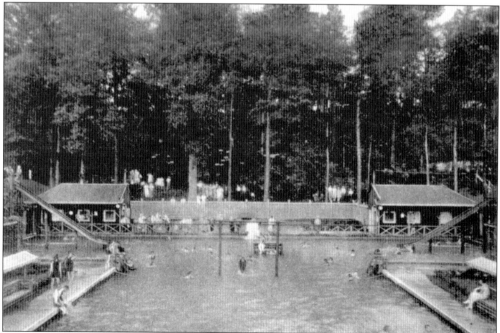

The T pool was extremely popular with visitors, but friction between polio patients and guests increased. Patients wanted their privacy, and guests did not want to swim with the "polios."

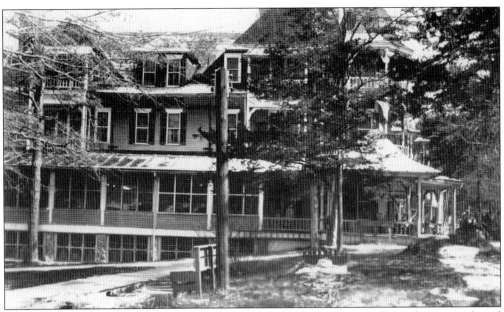

This side of the Meriwether Inn shows the basement where FDR and the "polios" were forced to eat. Aside from the discrimination, FDR began to observe other problems occurring. At this time, 80 Georgia banks including the one in Warm Springs closed. The Great Depression had not hit the nation, but Georgia and other rural areas in the South were experiencing the economic downturn in advance.

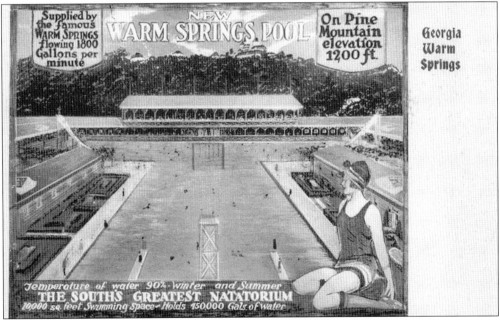

Hand-colored postcards were produced and distributed that touted the strength and temperature of the Warm Springs. As new owner of the resort, FDR tried many ways to encourage and promote tourism. In 1927, FDR wrote, "Aside from the therapeutic value, we have so many natural resources for the families or patients that the swimming, golf, riding and quail shooting ought to appeal to those in perfect health."

FDR invited Dr. LeRoy Hubbard, an orthopedic surgeon from New York, to Warm Springs. Conducting studies from June through December 1926, Dr. Hubbard concluded that the benefits of water therapy improved the muscular conditioning of polio patients. The American Orthopedic Association approved his recommendations, and the Georgia Warm Springs Foundation for polio patients moved closer to becoming a reality.

Helena Mahoney was the first physical therapist in Warm Springs. She supervised Dr. Hubbard's prescribed exercises with the patients, while recruiting additional "physios" from Peabody College in Tennessee to assist in these "experiments."

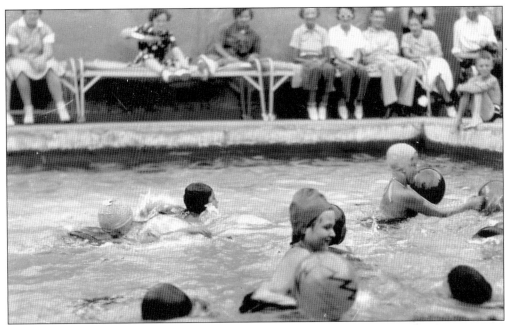

During Dr. Hubbard's experiments, therapist Mary Veeder observed: "Twenty-three patients were placed under observation for periods of five to seventeen weeks. They were given muscle tests, having these checked for improvement. This was done from June until December. All (patients) made improvements some by remarkable degrees. At the end of this period, a detailed report of each case was made to three orthopedic surgeons, all of whom had sent patients to Warm Springs. Each expressed unqualified approval and concurred in the establishment of a hydrotherapeutic center at Warm Springs."

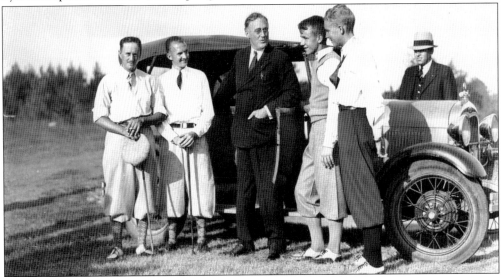

"The golf course comes along well and is going to be very good," FDR wrote to his mother. He commissioned Donald Ross, of Pinehurst fame, to enlarge the course from five holes to nine with plans for an additional nine-hole course later. Under the auspices of Bobby Jones, the course opened in July. Roosevelt still had hopes of bringing tourists to the playground he envisioned in Warm Springs.

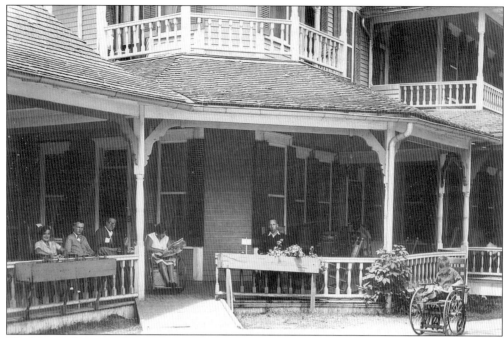

The Meriwether Inn of 1927, sitting pretty on the hillside, looked fashionable enough in pictures, but it was deteriorating at a rapid rate. Tourists had all but quit coming to Warm Springs as more and more "polios" arrived seeking help because of the stories circulating about the curative powers of the springs and the treatments being developed by FDR.

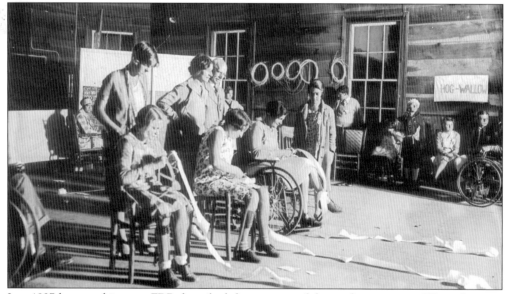

In a 1927 letter to his aunt, FDR described the progress of the work going on in Warm Springs: "Dearest Auntie Bye . . . I am sending you some of our folders about Warm Springs. The work of starting a combined resort and therapeutic center has been most fascinating for it is something, which, so far as I know, has never been done in this country before. . . . We have already 30 patients there this summer and our total capacity for this coming year will be only 50, a figure I think we shall reach in a few weeks."

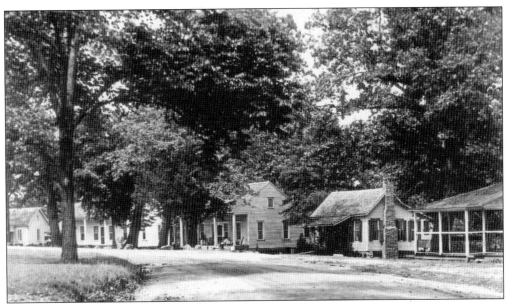

Cottages once owned by the wealthy seeking relief from the cities now became dormitories for the incoming handicapped visitors, who were mostly poor. Repairs were made as money allowed to convert these aging homes into fully accessible buildings that would accommodate wheelchairs. This cottage row became known as "The Colony." Money needed to refurbish the decaying cottages ran short as Roosevelt observed banks in the area beginning to close and many family farms failing.

Polio met its match in Franklin D. Roosevelt, and Mary Veeder recorded the following milestone in Warm Springs's history: "On July 28, 1927, the Georgia Warm Springs Foundation, backed by a number of prominent and public spirited men, was incorporated to be developed and administered without personal gain of profit. . . . Warm Springs was a way of offering people handicapped a way to live normal lives, a new hope, a new philosophy of thinking and a mental therapy which, after all, is the heart and soul of physical therapy."

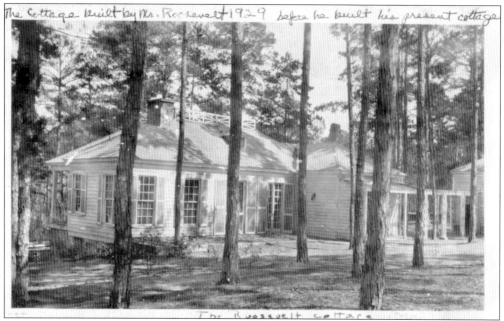

Roosevelt considered himself somewhat of an architect, and while residing in the Hart Cottage, he sketched some designs and hired architect Henry Toombs to finalize the plans and build him a cottage. This 1929 photograph of Roosevelt's first cottage, now known as the McCarthy Cottage, shows the back entrance and porch for easy accessibility.

One trademark of Toombs's cottages in Warm Springs was the floor-to-ceiling windows. FDR trusted Toombs and hired him to design Eleanor's cottage in Hyde Park, called Val-Kill. Toombs would also be instrumental in Roosevelt's future plans. As he settled in his new home, he saw many families lose their homes and farms as banks began to fail. The Great Depression was looming. Local newspapers began endorsing him as a candidate for president.

Throughout 1927, visitors from Detroit including Mr. and Mrs. Edsel Ford spent time in Warm Springs, deeply impressed with the work that was being carried out there. Polio patient Elizabeth Pierson came with them and built a cottage on the foundation grounds. Along with Mary Veeder, she recorded many events on camera. Many of their photographs, such as this scene of Eleanor Ford picnicking at "the Knob," are included in this book.

The Fords enjoyed their Warm Springs visits, and in 1928, they donated money that allowed FDR to hire Henry Toombs to design a hydrotherapeutic center. Edsel Ford, in a letter, described his gift: "Dear Mr. Roosevelt, Mrs. Ford and I are deeply impressed with the wonderful work, which is being carried out here at Warm Springs . . . I am sending a check for twenty-five thousand dollars, which I hope you will accept for the foundation with our best wishes for its complete success."

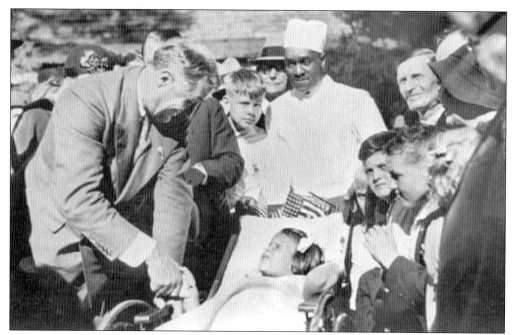

"Roosevelt the Reliever" was the 1927 headline from the *Atlanta Constitution*. It dramatized FDR's attitude toward the foundation. Referring to the project, the editorial remarked, "By that splendid benefaction, he will have served the world far more than he possibly might by four or eight years in the White House."

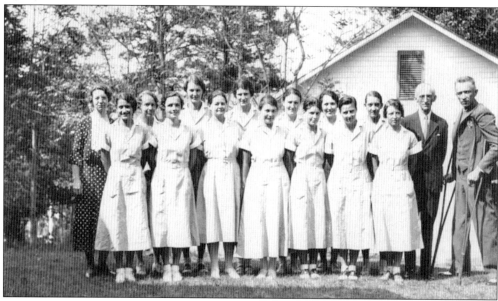

Roosevelt sent out a call for assistance, describing "A Pioneering Opportunity" for doctors and therapists. A foundation brochure stated thousands of people were partly or wholly crippled from polio. The foundation brochure continued, "I think most cripples, children or adult, are worth taking an interest in. Economically, this work is sound; humanly, it is right. We need pioneers." These young therapists, or "physios," from Peabody College answered Roosevelt's call for medically qualified help as they arrived in Warm Springs.

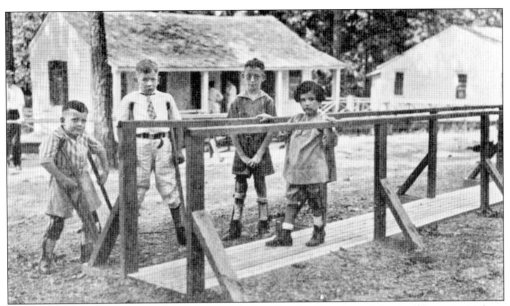

Therapy was established, and the physios worked under the direction of physical therapist Helena Mahoney. Mary Veeder wrote, "The walking exercises were done in the Colony in front of the cottages known as the Rec. There were several narrow ramps with bars for patients to walk down to strengthen muscles before they started crutch walking. After this walking, the patient was instructed in his particular gait, using crutches, canes, braces for his individual setup."

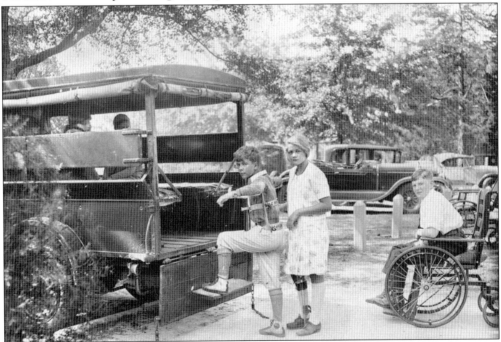

Noting the special needs each polio patient required, Mary Veeder observed: "No two polio cases are ever alike and each person has a different setup of muscle use; hence, it was all individual instruction. Also, there was one bus, or ambulance, that went up and down the hill on a schedule, so that the patient knew which bus to be at the pool for his treatment at a given time."

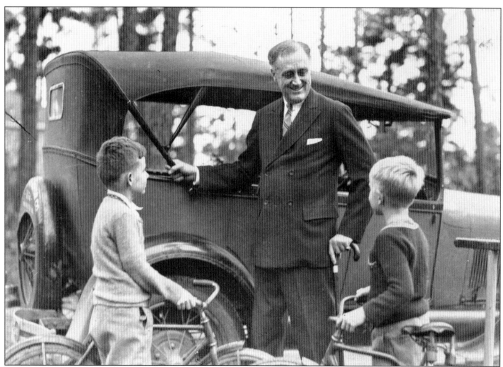

A favorite treat for children in Warm Springs was Franklin Roosevelt driving to town. No matter how busy he was, he would stop and get an ice cream cone or Coke for the kids.

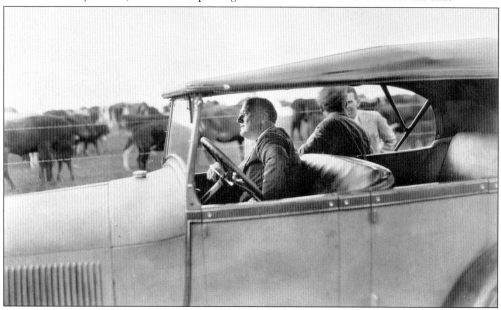

Roosevelt loved driving the countryside around Warm Springs, especially to his farm. He would drive for hours chatting with neighbors and enjoying the beauty the mountaintop offered. In an editorial for the *Macon Telegraph*, he wrote of his observations in Georgia: "Yesterday afternoon I went up to the top of Pine Mountain. There, stretching out for many miles to the horizon was a large portion of Meriwether County. It was good-looking country—and good to live in."

Roosevelt's tree farm at Warm Springs developed nicely throughout 1928. To him, it was not a hobby but a demonstration for farmers emphasizing the long-term investment potential. Roosevelt hired Ed Doyle (left) to oversee operations of the farm and Otis Moore to manage it. They are shown here among the longleaf pines that FDR had planted.

Arbors of grapes and muscadines were planted in one section of the farm. These fruits grew profusely in the sun, producing large quantities ready for jellies, preserves, and, most likely, homemade wine. FDR enlisted the services of Extension Agent W. "Tap" Bennett (left) to provide advice regarding the expanding operations.

"Tap" Bennett (left), Otis Moore (center), and Ed Doyle are seen here inspecting the peach orchards of the Roosevelt Farm. Not only did local farmers benefit from the practices put in place by FDR, the patients also enjoyed the fruits of the farm, along with fresh vegetables, meats, and dairy products.

FDR's cattle were his pride and joy of the farm, as well as the money crop. FDR did not want to spend money on the farm and felt that it would destroy its value as a demonstration. "For this reason, he rejected a gift of a carload of blooded cattle. He developed his cattle from poor native stock, being careful to breed the stock only to registered bulls," Otis Moore recalled.

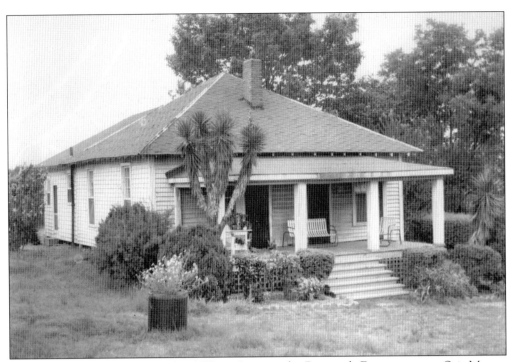

Located about three miles south of Warm Springs, the Roosevelt Farm manager, Otis Moore, lived in this house. After FDR's death in 1945, the farmland became part of the new state park named in FDR's honor, and the house was relocated to nearby Durand, Georgia.

FDR desperately wanted to return to politics but felt he was not quite ready. It was decision time, and he was alone. In a letter home, he expressed his thoughts: "Dearest Mama, I have had a difficult time turning down the Governorship, letters and telegrams by the dozen begging me to save the situation by running. . . . I only hope they don't try to stampede the Convention tomorrow and nominate me and then adjourn!" On October 3, 1928, four years after his first swim in Warm Springs, Roosevelt was nominated for governor of New York. On October 5, he made his way up the ramp and into political history.

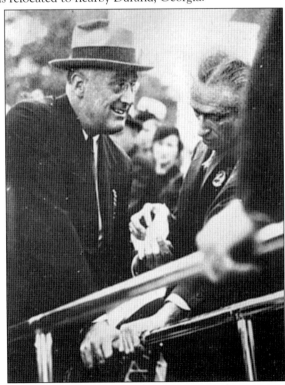

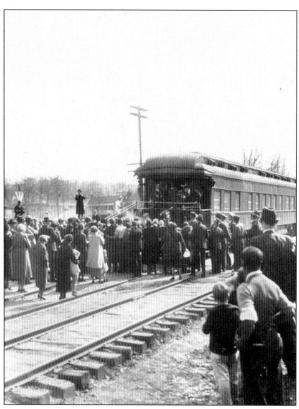

The townspeople gather and cameras snap as Warm Springs Foundation patient number 1 leaves for New York aboard the train. FDR, standing on the rear observation platform of the train, bids farewell to his most faithful supporters, the people of Warm Springs. Four years earlier, he had arrived in Warm Springs with his career all but over. When he returned for the Thanksgiving holiday that November, his political career was just beginning. His accomplishments, observations, and efforts of the past four years, all lessons, would not be forgotten.

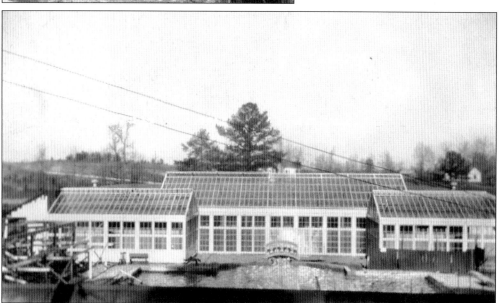

When the New York governor returned to Georgia on November 8, a celebration was in store. The new Edsel Ford pool, along with a parade, greeted him as Warm Springs accorded him an ovation "such as no man has ever been accorded there before." Nearly 1,000 people met him at the depot to show their support. Not disassociating himself from his Warm Springs background, Franklin D. Roosevelt called for farm relief in his home state of New York.

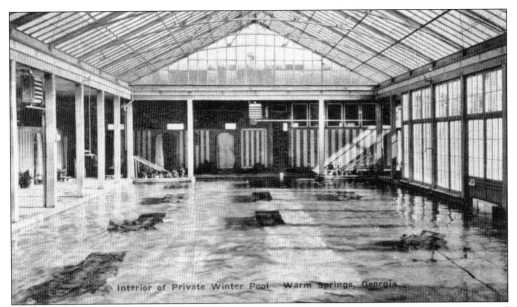

Looking more like a country club resort than a therapeutic center, the enclosed pool, named after Edsel Ford, awaited its patients. The glass enclosure allowed sunlight to stream in. During winter months, heated air in the pavilion made swimming a pleasant experience. These postcards circulated throughout the country calling it the "Private Winter Pool."

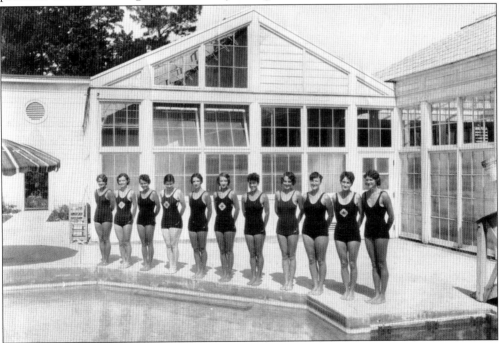

Excitement is on the faces of these young ladies from Peabody College, Tennessee, as they pose for the first group photo at the new pool. This photo is from Mary Veeder's scrapbook. Standing from left to right are Phyllis DeBrick, Martha Parker, Vera Rickman, Louise Mims, Mary Hudson (Veeder), Nancy Watson, Dolly LeMay, Elizabeth Ann Lowe, Lucille Daniels, Gladys Osbourne, and Francis Holmes.

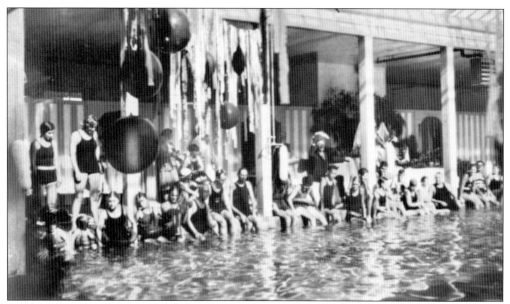

On Thanksgiving Day, 1928, Franklin Roosevelt waved his handkerchief, signaling the patients to enter the new pool. The day was full of activities that culminated in a glorious feast that evening. This event became known as Founders Day in honor of the founder, full of celebration for the future as well as accomplishments of the past.

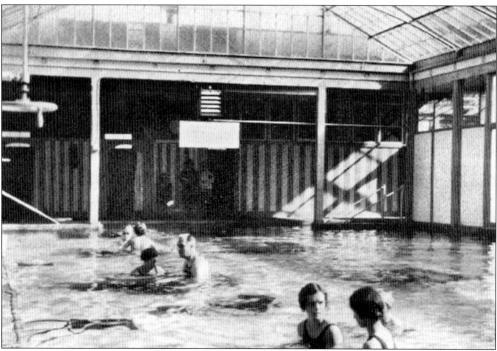

When FDR reentered the political world, he had for all practical purposes ceased his recovery. His time was now demanded elsewhere. He would, however, have water therapy as much as possible. He is seen here with Helena Mahoney.

Even in autumn, there are warm sunny days in Georgia that make for a pleasant swimming experience, if the water is 88 degrees. Roosevelt is seen here with little patients at the outdoor play pool.

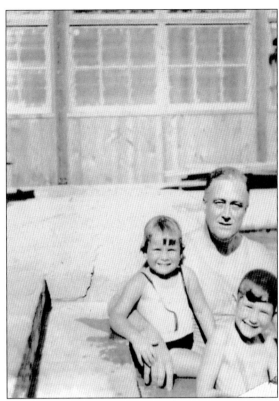

On the day of his return to Warm Springs, a parade was given in honor of Governor Roosevelt. The same Tally-Ho that once carried passengers from the depot to the Meriwether Inn was now used as a parade carriage for George and Martha Washington. Physios dressed up like the founders of our country, and Mary Veeder is pictured here as George. Fred Botts climbed aboard as the coach master, and the procession headed to downtown Warm Springs.

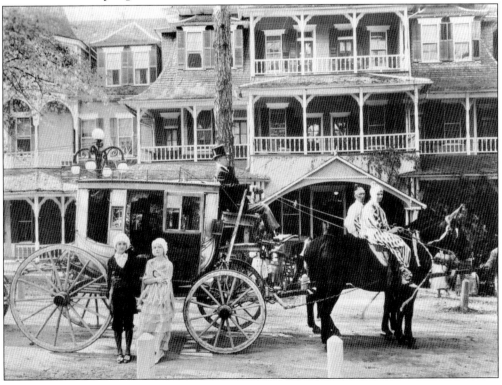

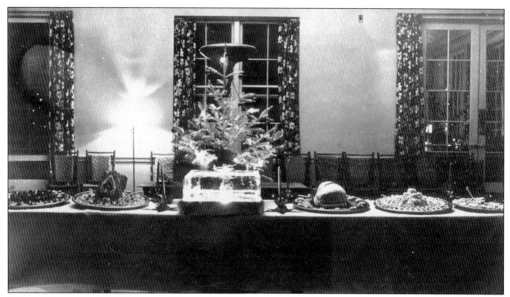

The table is set with turkey and all the fixings inside the old dining hall of the Meriwether Inn. FDR, who would sit at the head of the table, would carve the turkey while reminiscing about the past and looking forward to the future. Politics would be left behind as Warm Springs was a place of healing.

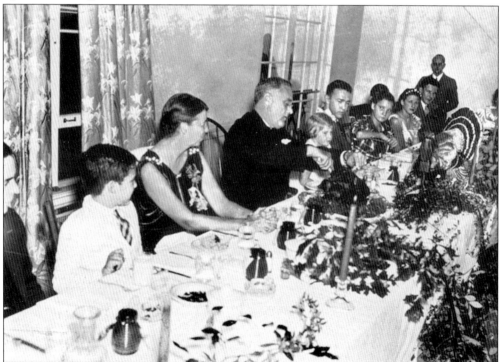

Seated at the head of the table, Roosevelt with the patients at his side carves the first Founders Day Thanksgiving turkey in the old Meriwether Inn in 1928, concluding the day's activities. At the end of the feast, FDR stood by the door to greet and shake the hand of every patient. This is another tradition he would keep throughout the years.

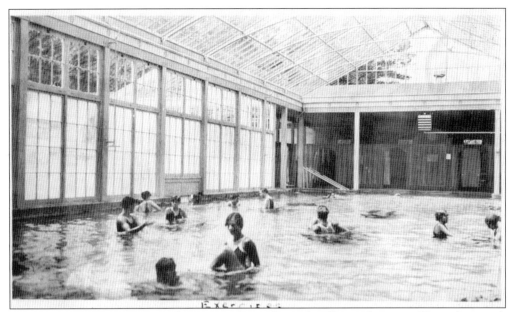

Therapy began immediately in the new pool complex with a flurry of activity. The indoor pool, used as a place of celebration on Thanksgiving Day, now became the scene of serious work. The exercises developed by FDR, Hubbard, and Mahoney over the years were being ever improved upon in order to return patients home with new skills, mobility, and a renewed sense of esteem.

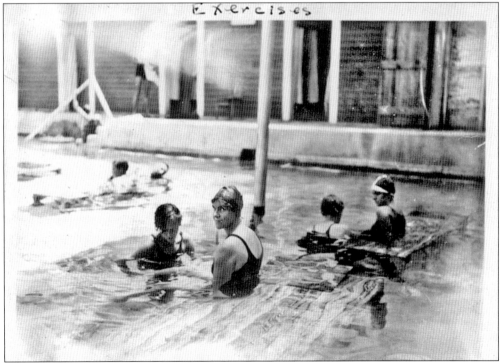

The camera was ever present to record the exercises being used in Warm Springs. These images were not only used as candid shots of life at the foundation, but for study. They recorded areas that needed improvement or successful techniques to be repeated.

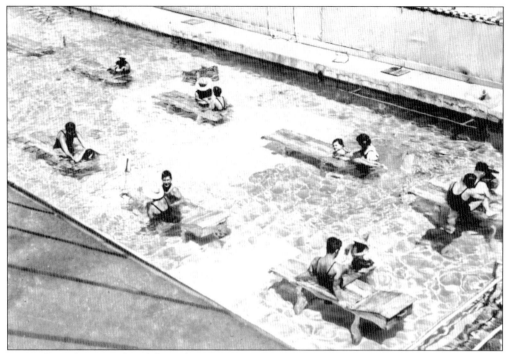
Water from the springhead flowed first into the shallow Exercise Pool; next it filled the deep-water Play Pool, and then the enclosed Winter Pool. Flowing at over 900 gallons per minute ensured that the water would remain warm as it flowed from the therapeutic pools and finally filling the Public or T Pool.

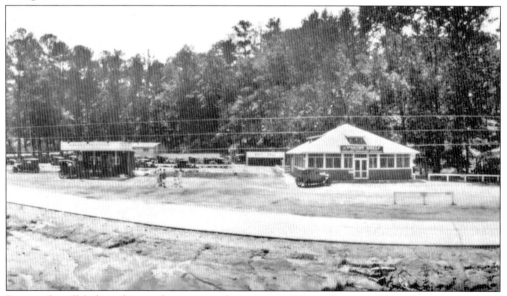
Roosevelt still believed in and encouraged tourism in Warm Springs. This photograph of the picnic area, snack bar, and service station located near the Public T Pool offered comforts to the travelers. He envisioned Warm Springs developing into a playground and called for better roads as one measure to encourage travel to Warm Springs. With the Great Depression now in full swing, money had become scarce.

As each polio patient needed braces, skilled craftsmen were required. One local, John Railey, was selected by Dr. Hoke to start the brace shop in this little building next to the Bradley cottage. The pioneering efforts made by the brace makers would become internationally famous in the area of adaptive technologies.

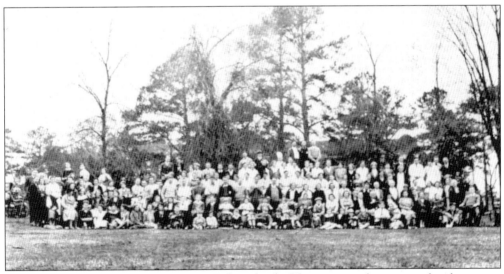

In many ways, Warm Springs experienced a rebirth. The springs, always considered a source of healing, were now being put to the test. Patients now outnumbered the tourists, and their number would continue to grow as the epidemics occurred. These patients developed friendships, and everyone considered themselves part of a family. Group photos like this were often taken as mementos.

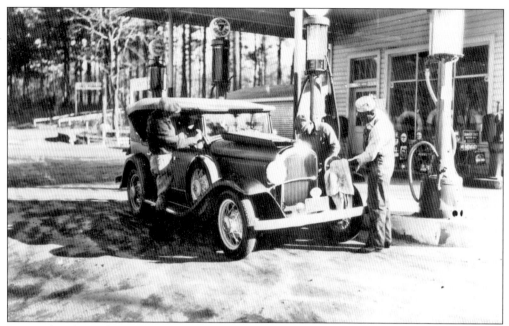

Roosevelt is shown here in his Plymouth having his car serviced. Roosevelt is leaning over talking with an attendant on the passenger side while others check under the hood and clean the lights. His travels throughout the Warm Springs and Pine Mountain region brought him face to face with the plight of many people who were experiencing the effects of the Great Depression.

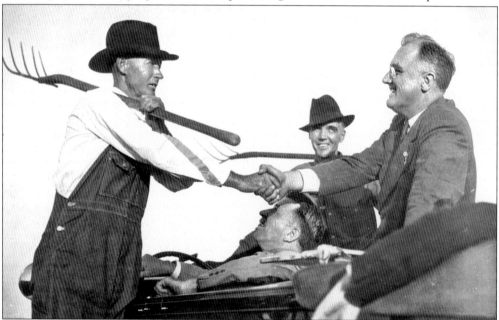

FDR established a relationship with the people of America. They felt like he was their friend. He was able to relate to the "common man" because of his experiences in Georgia. Arthur Carpenter notes: "Many a family in Meriwether and adjoining Harris Counties owed their first acquaintance with Franklin D. Roosevelt to the fact that he had driven to their dooryard for a friendly chat. He knew them, knew their troubles and problems, as well as their joys."

Six

THE LITTLE WHITE HOUSE

The country needs and, unless I mistake its temper, the country demands bold, persistent experimentation. It is common sense to take a method and try it. If it fails, admit it frankly and try another. But above all, try something.

—FDR, May 1932

On December 15, 1931, Governor Roosevelt sent a check for $1,500 to begin construction on a cottage in Warm Springs. He called upon the skills of Henry Toombs who had earlier built cottages for him in Warm Springs and New York. Now Toombs was charged with building a six-room house overlooking a deep wooded ravine on Pine Mountain. Roosevelt selected the site while horseback riding with Fred Botts. Botts remembered him saying, "I'll build me a cottage here and begin my new life." FDR's plans included a sundeck shaped like the fantail of a ship where he could work and enjoy the scenic vistas and sunsets. FDR used only local materials, the longleaf pine and stones from the mountain, for the construction. Daniel Construction Company was hired to build the house, and by May, it was completed. Roosevelt signed the invoice for $8,738.14, and afterward he announced his candidacy for president before the patients and townspeople of Warm Springs. He and Eleanor threw a housewarming party for everyone in the area. The entire party cost $31. Roosevelt now had two homes in Warm Springs, and he wanted to rent them while he was campaigning. In a note from Arthur Carpenter to the foundation accounting department, he asked to set up two accounts in the governor's name. To distinguish the accounts, he said, "Call the new cottage the Little White House." The name stuck. When President-Elect Franklin D. Roosevelt returned in November 1932, the nation was mired in the Great Depression, and the people looked to FDR for hope. Some of the most far-reaching policies of the New Deal would be fashioned under the slate roof. The eyes of America focused on the tiny community of Warm Springs, Georgia, and Roosevelt's Little White House. The education FDR had received while in Georgia was about to pay off.

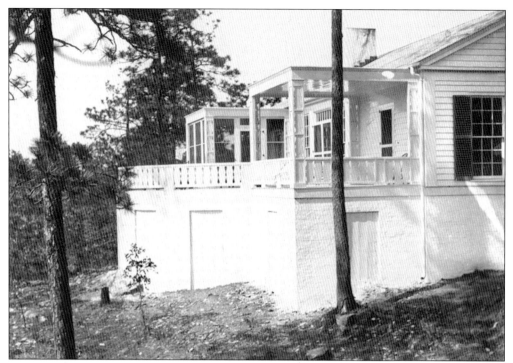

Toward the end of April 1932, the Roosevelt family arrived in Warm Springs and made sure that the cottage was fitted and ready for occupancy. The sundeck commands beautiful views sitting high above the ravine. The window to the right is FDR's bedroom window.

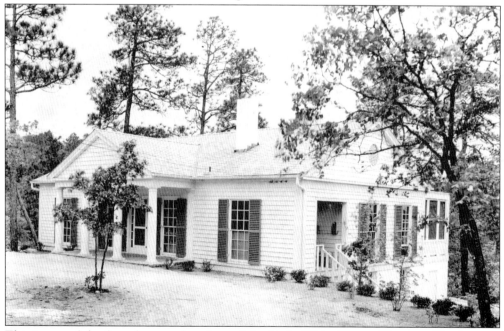

This is one of the first photographs taken of the Little White House. Thurston Hatcher was commissioned by the *Atlanta Journal* to travel to Warm Springs and photograph the cottage as well as FDR in some formal portraits, showing him in a presidential posture.

Franklin D. Roosevelt, candidate for president of the United States, sits in his Little White House before the native stone fireplace. This is Roosevelt at the dawn of his new political career, and he is at the height of his physical health. This photograph by Hatcher is the first known of FDR in the Little White House.

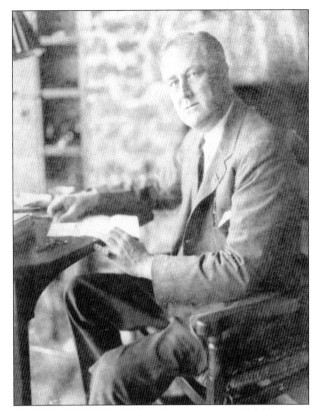

The combination dining and living room is furnished from Val-Kill Industries. This was Eleanor Roosevelt's shop in Hyde Park that was used to hire unemployed craftsmen to produce furniture and pewter goods. The table and buffet are made from maple as is most of the furniture in the cottage. Val-Kill furnished many of the cottages at the foundation.

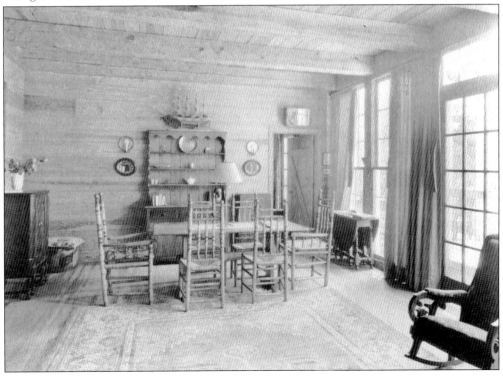

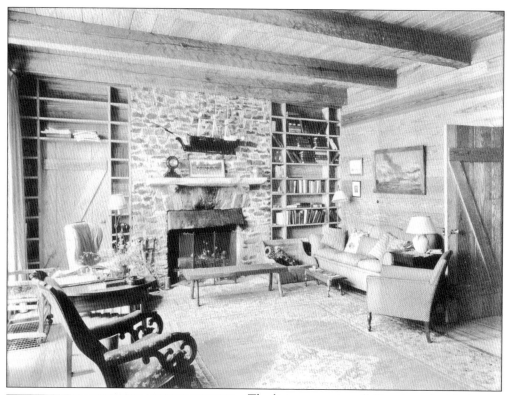

The living room is well illuminated with the floor-to-ceiling windows allowing sunlight to flow into the room. Within months, this room would host press conferences, cabinet meetings, and high-level discussions about the American people as the president took on the Great Depression. The whaling ship above the mantel was made from scrap wood by FDR and one of his bodyguards.

This husband and wife team, Irvin "Mac" and Elizabeth "Lizzie" McDuffie, served President Roosevelt not only in the Little White House but also in Washington. Irvin was FDR's valet and barber for 12 years, while Lizzie served as housekeeper and confidante to the Roosevelts for 18 years.

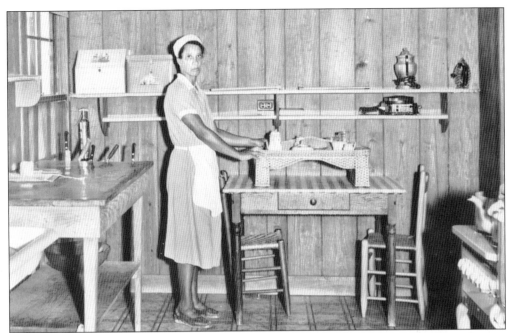

Mrs. Daisy Bonner, devoted friend and cook of Franklin D. Roosevelt, came to Warm Springs to work at the Meriwether Inn. Daisy would go on to cook for FDR nearly 20 years until his death in 1945. FDR especially enjoyed her country captain (a chicken dish), Brunswick stew, and black nut cake.

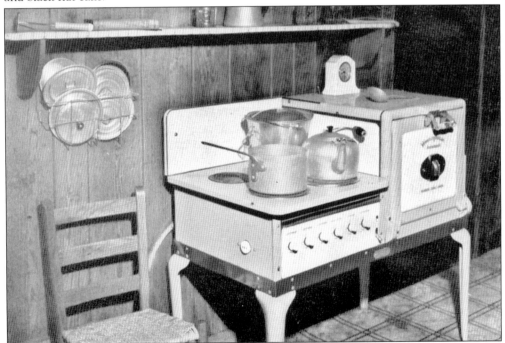

The Westinghouse electric range is probably the most modern convenience in the Little White House. There is no refrigerator, only an icebox to keep foods fresh. It sits outside near the kitchen entrance.

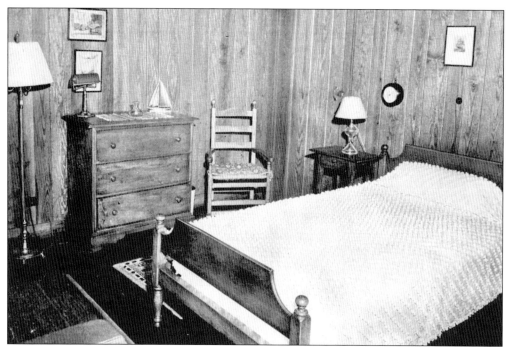

FDR's bedroom, as well as the other bedrooms, was also furnished by Val-Kill Industries. The bed is a three-quarter length, and the nautical theme seen in the bedroom is repeated in every room of the cottage except for the kitchen.

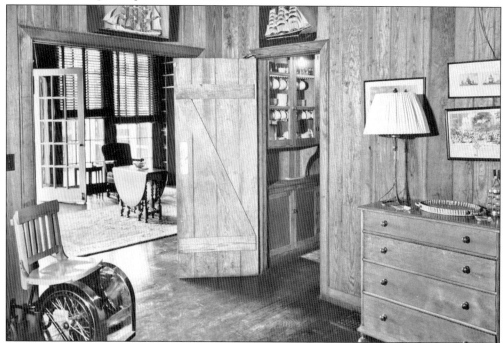

The foyer of the cottage also served as a waiting and reception area. It could be closed off if the president wanted privacy in the living room. The passageway leading to the right enters the butler's pantry just before the kitchen. One of Roosevelt's own designed wheelchairs sits in the foyer

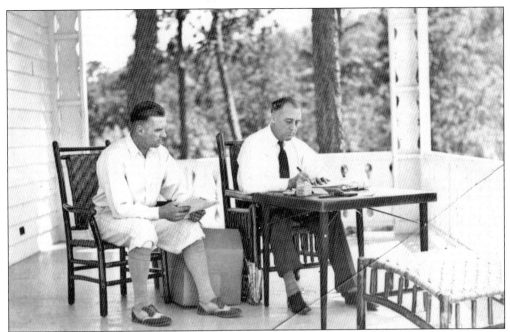

FDR loved working on his sundeck. He would have his card table placed there where he could enjoy the sunshine and fresh air. He is shown here with Earl Miller, one of his bodyguards.

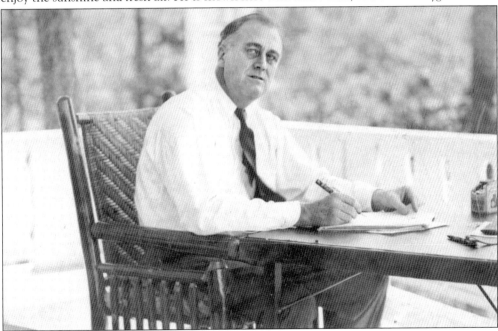

Sitting on the sundeck of his new cottage in May 1932, FDR is about to launch his national campaign for president. Soon he would leave Warm Springs to address the graduating class at Oglethorpe University in Atlanta on May 22. He told the students there that the country needed and demanded bold experimentation from government. The Great Depression grew ever deeper, and the hope of jobs for the class was dim. FDR inspired the hope and went on from Warm Springs to receive the Democratic nomination for president.

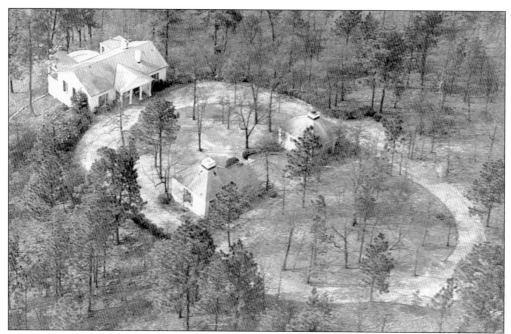

An aerial view to the grounds around the Little White House shows the guest (left) and servants quarters above the cottage and within the circular dirt driveway. The garage is located below the servants quarters.

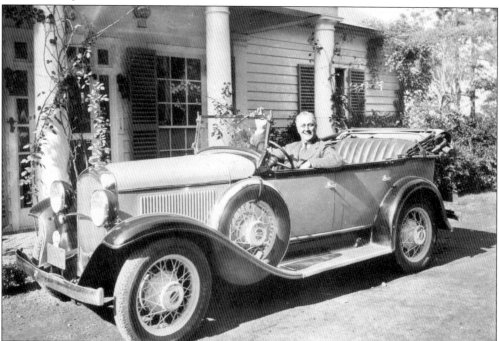

FDR sits in his Plymouth and waves for photographers during this shoot. He would soon leave Warm Springs on his nationwide campaign to win the American vote. Scenes like this are how the nation came to know Franklin Roosevelt, sitting in his car, visiting and speaking to common people across the country.

As the 1932 campaign wound down, Roosevelt in Warm Springs allowed members of the press to autograph his hat. Foundation patients even wrote a song about it. In an *Atlanta Journal* news clipping, FDR is recorded commenting about his old grey hat: "Two more weeks to go. . . . First, let me say this: this old hat, a lot of you people have seen it before. It's the same hat. But I don't think it is going to last much longer after the 8th of November. . . . I have a superstition about hats in campaigns, and I am going to wear it until midnight of the 8th of November."

Excitement of the times can be seen on the face of Roosevelt sitting in his automobile outside the old Meriwether Inn during a visit with the patients.

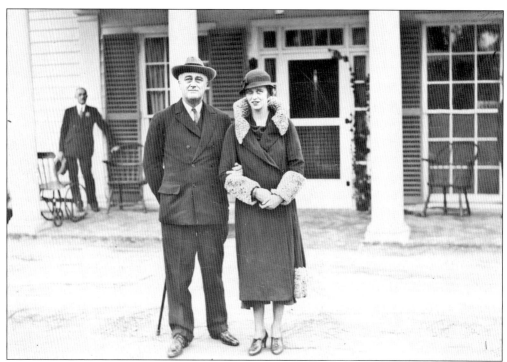

In the background, FDR's wheelchair is placed outside the Little White House. Only three published photographs exist of FDR sitting in one. Here he is standing for the photographer with his daughter, Anna. His grip on her arm is so tight it pulls her shoulder down slightly. He is using his cane as a prop behind him.

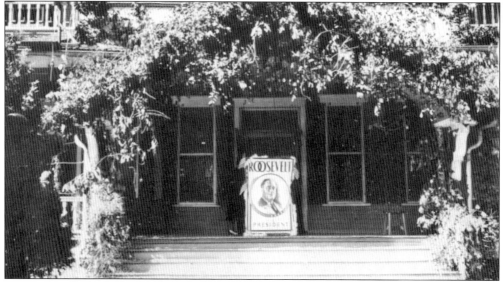

Sitting outside the Meriwether Inn, a poster proudly proclaims "Roosevelt For President." More than anybody in the nation, the patients and people of Warm Springs knew FDR best. They had seen him struggle, seen his weaknesses, and knew his strengths. Through example, he taught the patients that there was nothing to fear but fear. This was something he would share with a worried nation.

Seven

WARM SPRINGS AND A PRESIDENT

May I thank you all, I don't have to say that it comes from the bottom of my heart, because you know that it does. I am awfully glad to be back home again with my neighbors in Meriwether County and Warm Springs."

—FDR, November 1932

On January 30, 1933, as Adolph Hitler became chancellor, president-elect Roosevelt celebrated his birthday in Warm Springs with dozens of handicapped children. The nation was excited with hope and confidence in FDR. But there was not a happier group of folks in America than the people in Warm Springs. They had seen Franklin Roosevelt, patient number one, overcome many hurdles. The stigma of polio was often more handicapping than the disease itself. Although he never walked completely on his own again, he had developed a technique at Warm Springs that appeared as if he could walk using a cane. Using his left hand to grip the right arm of his bodyguard or family member who held him up, he heaved his useless legs forward. The cane acted as a prop. This was a tremendous physical struggle, but he knew that if he were confined to a wheelchair, his political aspirations would vanish.

Everyone had heard about his recovery using the waters of Warm Springs and his effort to aid other suffers at the foundation. For his next birthday in 1934, the people of America took up a collection; they danced, holding numerous fund-raisers across the country and sending $1 million to the Georgia Warm Springs Foundation. These "Birthday Balls" would continue until 1938, when the fund-raisers would give birth to the National Foundation for Infantile Paralysis or March of Dimes. Roosevelt wanted every polio patient to receive the same kind of care, where they lived, that Warm Springs patients received.

What FDR experienced in Warm Springs was translated to the American people. The high cost of FDR's first electric bill at the Little White House would give birth to the Rural Electrification Administration or REA. He had observed banks collapsing and farmers struggling. As a result, the nation received the Federal Deposit Insurance Corporation (FDIC), the Agricultural Adjustment Act (AAA), the Tennessee Valley Authority (TVA), and the Civilian Conservation Corps (CCC), along with many other programs designed to lift the country out of the Great Depression. In 1945, after being elected president for a fourth term, Franklin Roosevelt returned to Georgia seeking what he had come to rely upon during his most troubling days, the "Spirit of Warm Springs."

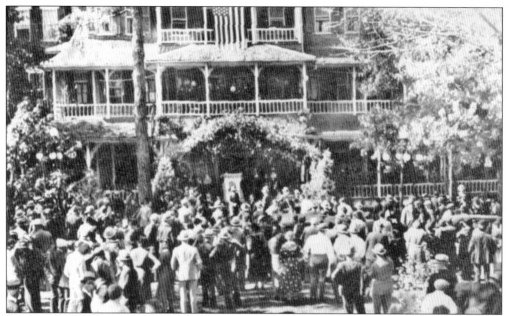

In October 1932, hundreds of thousands lined the streets of Atlanta, Georgia, to get a glimpse of their future president. The *Atlanta Constitution* printed, "Today Georgia welcomes him in heartfelt, joyous acclaim, a modern Moses who is to lead a darkened America out of a wilderness of depression." Millions felt this expression of hope as Roosevelt headed to Warm Springs to speak with his neighbors, polio patients, and the children at the Meriwether Inn. A couple of days' rest in the Little White House would reenergize him for the final campaign stretch.

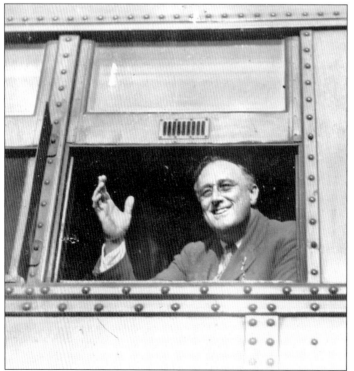

Off to New York to await the November 1932 election results, FDR waves goodbye from his train at Warm Springs in a scene that was most familiar to his neighbors. Thanking his well-wishers, Roosevelt spoke briefly before departing: "Well, It's fine to see you, and I'm looking forward to coming down here for the usual Thanksgiving party at Warm Springs, and having a real old-fashioned Thanksgiving with my neighbors again. I thank you!"

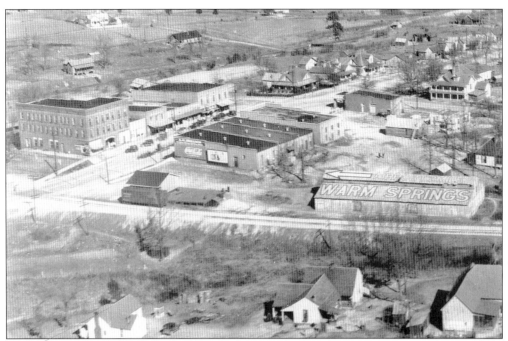

When a president goes on vacation, the photographers follow. During the 1930s, as technologies improved, aerial photographs of Warm Springs show how little the town had changed. During the next few years, the town would change as well as the foundation. The water, however, remained constant at 88 degrees, and FDR, bound by the water, relied on its soothing qualities to restore his strength, emotionally and physically, during his most troubling days.

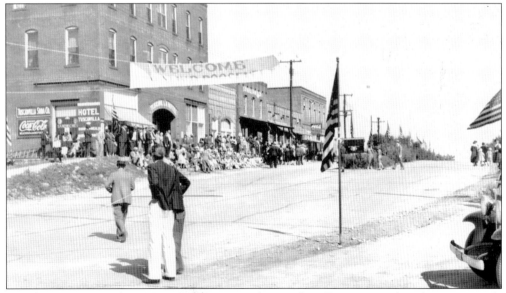

Another victory parade in Warm Springs awaits the president. Four years earlier, the townspeople had given their neighbor and the governor of New York a parade. This time, it was for the president of the United States. Presidents had not often traveled to Georgia. Now President Roosevelt was coming to celebrate his Thanksgiving holiday with them and his most loyal supporters, the patients at the foundation.

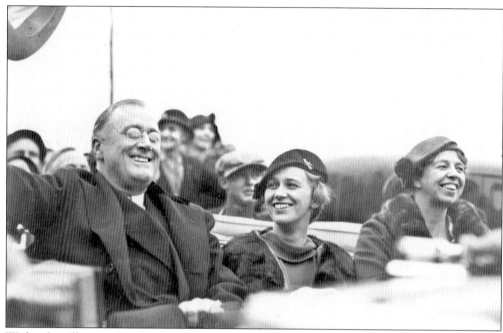

With a friendly toss of his head, his chin high, and waving his hat, President Roosevelt is seated beside his daughter, Anna, and Eleanor as they leave the depot for the foundation to say hello to the patients. From there, the party would settle in at the Little White House and prepare for the evening's feast.

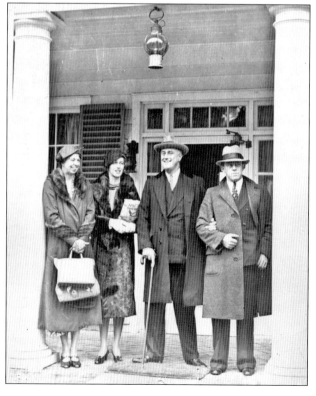

The Roosevelts pause for the photographers in a candid moment at the Little White House. Standing to FDR's left is his bodyguard, Gus Gennerich.

While the ladies settled in at the Little White House, FDR climbed aboard his Plymouth and went driving around the foundation, checking on its progress.

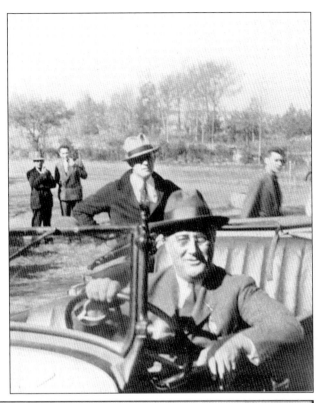

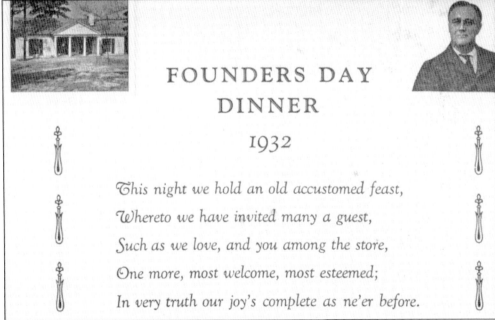

Invitations sent out for the Founders Day feast included a picture of the president and the Little White House along with the poem that highlighted the fondness the patients had for their president while recalling that Thanksgiving in Warm Springs was a custom. He would never break it after an election.

A Warm Springs Thanksgiving for FDR and the patients was filled with laughter, music, and memories. After dinner, FDR maintained a custom of greeting the patients: "So tonight there are a lot of new faces and a lot of old faces, of grown-ups and younger people, and a little later I want to go out to the door as I have done since 1925 or 1926, and greet you personally and clasp your hand."

FDR celebrated his 51st birthday in Warm Springs on January 30, 1933. He had not yet been inaugurated, and the air was filled with excitement. Many of the local townspeople and patients in Warm Springs received invitations to attend the inauguration in March. FDR had set aside a special reviewing stand for his friends as his guests of honor. In 1934, the nation celebrated the president's birthday by holding fund-raisers for the foundation across the country.

Roosevelt's overall health improved in the naturally buoyant waters of Warm Springs, but he never attained complete recovery from his paralysis. In a letter home, he expressed his confidence in the mineral waters: "The legs have really improved a lot. There is no question that this place does more good than all the rest of the exercising etc., put together."

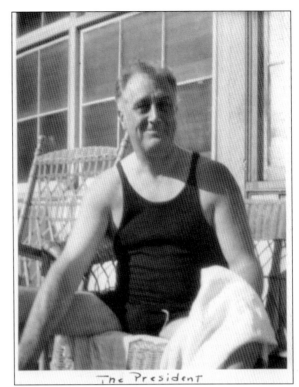

The President

Roosevelt loved to play ball in the water with the children. They played energetically and all enjoyed the roughhousing, especially when it came time to dunk the president.

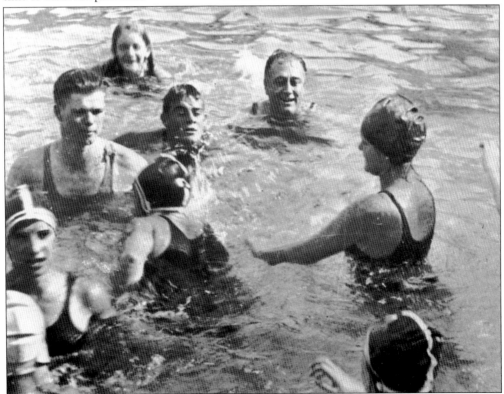

The president of the United States must be protected. Located near the Meriwether Inn was a company of U.S. Marines. Their bivouac became fondly known as Camp Roosevelt.

A special treat for the children at the foundation and locals of Warm Springs was when the president reviewed his guard.

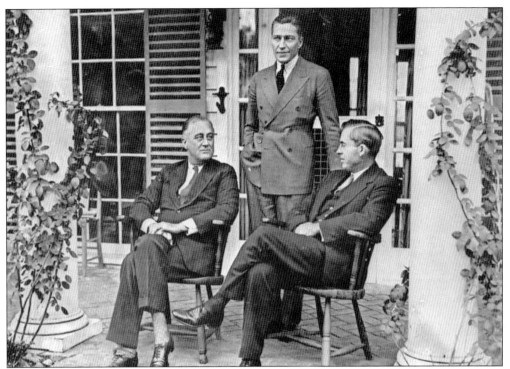

A cabinet conference in Warm Springs, Georgia, makes the headlines as members of FDR's "Brain Trust" direct policies that will shape everyone's life in America. Seated right is Henry Wallace, secretary of agriculture and future vice president in FDR's third term. Eugene Vidal, director of aeronautics, is standing.

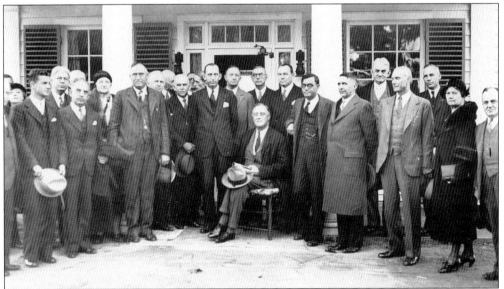

Warm Springs was a place where FDR could relax, but as president, many people demand his time, and there were many debts to pay. He is shown here with many prominent citizens of Meriwether County and other Georgians who showed their support during the elections in front of the Little White House.

FDR loved picnics. He had Arthur Carpenter build a stone grill at Dowdell's Knob, the highest point on Pine Mountain and part of FDR's property. He would often take his business associates there and perform official duties while overlooking the Pine Mountain Valley and eating hot dogs. Joseph Kennedy is seen in this photograph to FDR's left, wearing the sombrero.

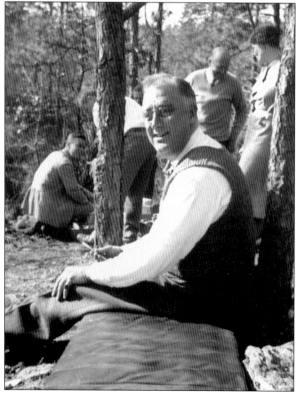

Pulling the seats out from their automobiles, the picnickers made comfortable seating on the rocky hillsides of Pine Mountain. Images like this would be taken through the years of the president on picnic. This photograph was used as a model for the statue that is being placed at the Knob where visitors can sit on the car bench and have their photograph taken.

Eleanor Roosevelt and the other ladies knit and chat while the men just talk on the hillside. Not seen are the troops in place behind the trees in order to protect the president. There were no restrooms on the mountain and stories have circulated around Warm Springs of people having to go that would stumble on a soldier near the perfect hiding tree.

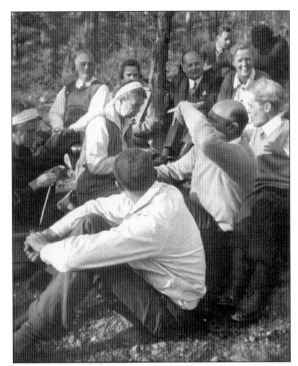

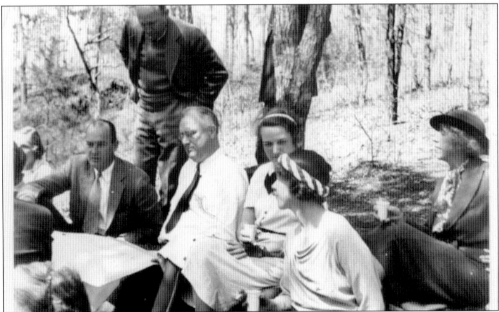

Picnics were a favorite pastime of Roosevelt's. There he could relax, plan, and simply enjoy the views of Pine Mountain. After one picnic, FDR spoke with the patients at the foundation and commented about its progress: "Every year that I come down here I go over blueprints. I went out to a picnic yesterday afternoon and I spent a good part of the time looking at blueprints. Well, those blueprints show us the Warm Springs of the future only so far as we today can analyze. I am quite confident that in the next twelve or fourteen years we are going to make even greater progress than we have in the past."

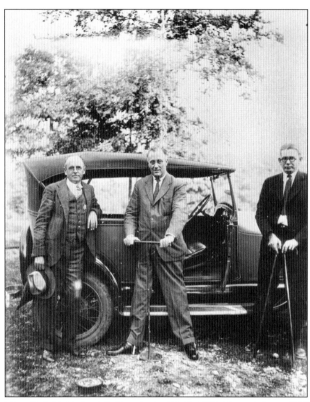

FDR prepares to turn the wrench that will send the water to the holding tanks of the new water system, ensuring that the fire department would have enough water in an emergency. He often expressed his thoughts about the old wooden structures: "Before the old firetrap of a hotel was torn down, we got to the point where we had over two hundred people in the old hotel dining room and . . . the old hotel had sunk six inches into the ground. When we heard that, we decided that that kind of place for people to take treatments in and live in was just too dangerous to life and limb. That was the origin of the newer Warm Springs."

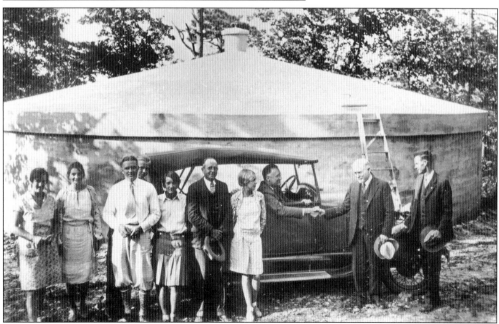

The force of the springs is so strong that FDR created a water system for the foundation. Pipes from the springs led to a tank nearly a half-mile up the mountain. From there, the spring water was gravity-fed to the cottages and hotel. He is seen here dedicating the water tank from his Plymouth.

Fire was always a concern at the foundation. In 1933, fund-raising began for a new reception hall and dining room that could replace the aging Meriwether Inn. Led by incredible efforts of Cason Callaway and Cator Woolford, the drive netted enough money to build Georgia Hall.

In November 1933, FDR gathered those responsible for building Georgia Hall and thanked them: "I express my appreciation and thanks, first, to you my neighbors of Warm Springs and Meriwether County, for your true friendship toward me and toward all those who have come here . . . and made me feel prouder than ever to call this 'my other home.' " FDR made these remarks at the dedication of Georgia Hall. The Meriwether Inn, no longer needed, sits empty in the background.

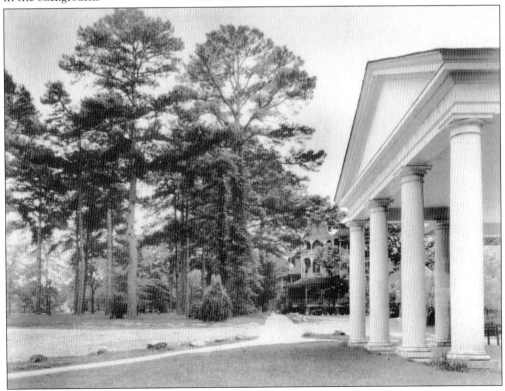

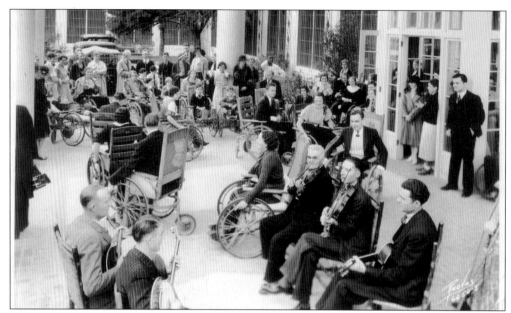

Local musician Jacob "Bun" Wright and his band entertained the patients on dedication day at Georgia Hall. Patients could now eat in a dining room that was made to accommodate wheelchairs. That evening, FDR, seated at the head of the table carving the turkey, spoke with the patients while reminiscing: "In 1932 we passed the 300 mark and we had 310 people who sat down in the old dining room for Thanksgiving evening . . . and it was so many people that the old dining room sank three inches."

FDR spoke with patients at the dedication, saying, "I wish much that people all over the country could be with us here tonight to learn of the splendid effectiveness of the work we are doing; to see this beautiful building which for all time will be the center of our work, and especially to understand that thing which we call "the Spirit of Warm Springs," which does so much to supplement the skill of science."

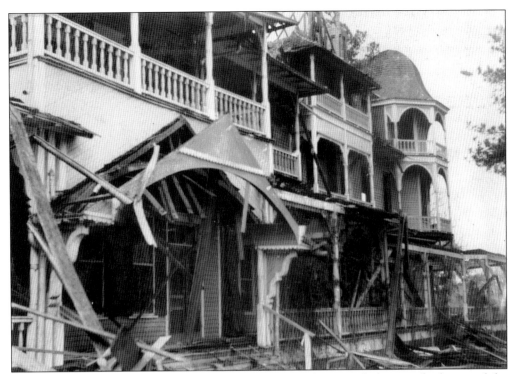

The Meriwether Inn was dissembled in 1934. It had held a special place in the hearts of the patients as a place where polios could recover. But it was a firetrap. It had served for decades as hotel and home. It was now falling apart. Where the front door of the inn was located, a stone tablet has been placed that states that the inn was removed "with relief and regret."

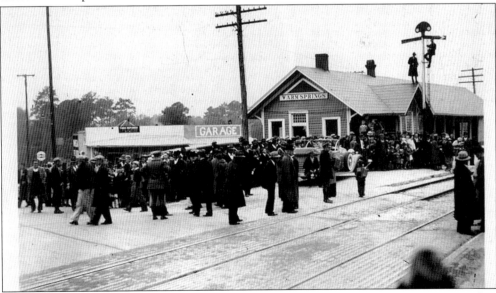

When FDR was elected for his second term, the old depot at Warm Springs again came alive with press and citizens awaiting the arrival of the president. When the press commented about his second victory and asked if he was going to vacation someplace special, he told them, "Warm Springs, I'm going to Warm Springs."

93

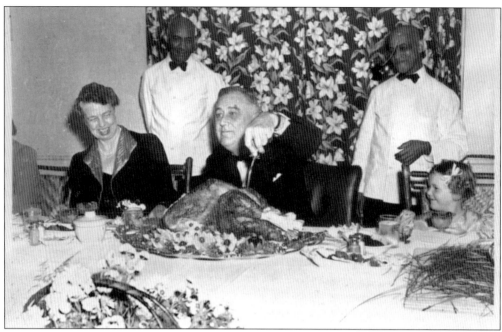

The tradition of carving the turkey and having a child sit at Roosevelt's side was something the children looked forward to each year. Contests were held to see who could sit closest. One young patient, Suzanne Pike, who was a non-polio patient, stood up using her braces for the first time, so she was invited to spend Thanksgiving dinner with the president. She never left Warm Springs and became a tour guide for the Little White House.

Funds collected from the Birthday Balls continued, and the foundation became financially solvent for the first time. Many improvements were made to make totally accessible cottages and pathways leading to all points on the "Campus." The foundation was designed to look like a university, never a hospital. FDR believed that education of the mind was as important as reeducation of the body. It is still referred to as the "Campus" today.

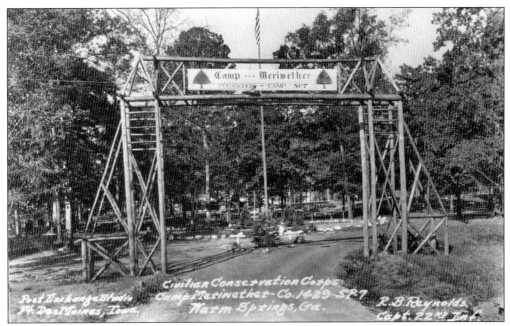

Camp 1429 of the Civilian Conservation Corps or CCC was one camp the president took special interest in the progress of. It was located adjacent to the foundation and pools. "I have seen the work that this camp and the Chipley Camp have performed in the last couple of years. You are rendering a real service, not only to this community but to this part of the State and the whole State," Roosevelt commented to the young workers on a visit to their camp.

President Roosevelt, speaking to the enrollees at Camp Meriwether, told the group: "It is permanent work. It is work that is going to be useful for a good many generations to come. That is why, one reason why, the people of this country as a whole believe in the Civilian Conservation Corps and, even when times get better as they are getting better, we are going to manage some way to dig up enough money in the Federal Treasury to keep the CCC going as a permanent institution."

In his short address to the camp workers, Roosevelt continued by saying, "I see this has become a really historic camp. You have been kept going here about as long as any camp in the United States, and I hope very much that we can find enough work to keep this camp going for a couple of years. I talked to you last year and the year before about yourselves—about the look in your faces and the good it has done to you."

FDR was often called upon to give a speech in nearby communities. Locals who recorded these events with their cameras donated their pictures to the Roosevelt Institute archives; however, in many cases, what and when the occasion was is unknown.

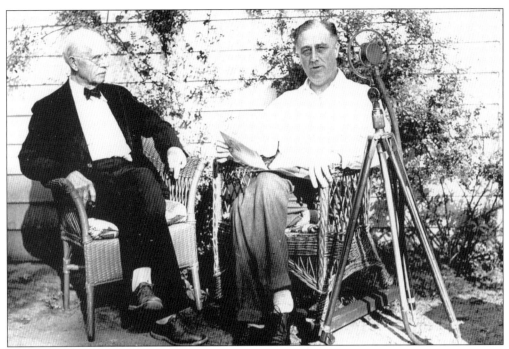

Many who never heard FDR in person remember him for his Fireside Chats and radio addresses. His voice beamed in the living room of every American. The nation stopped and listened to what he had to say. In this photograph, he is seated outside his cottage with Dr. LeRoy Hubbard preparing for a radio address to the nation from Warm Springs, Georgia.

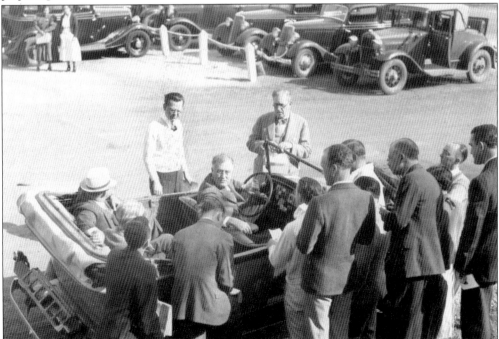

The roadside press conference was not an uncommon site in Warm Springs. The president would pull onto a clay road and eager reporters gathered around in hopes of a scoop.

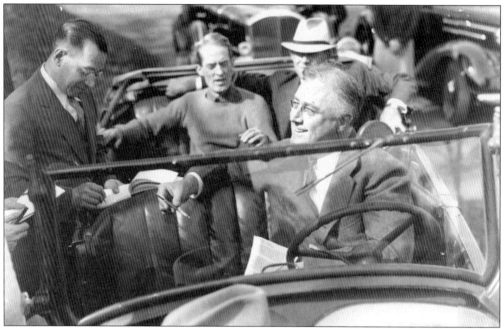

When the press asked FDR how he had come up with the Tennessee Valley Authority, he stated that while in the Little White House, he drafted an outline that developed into the TVA. After living in the South, FDR had taken a deep interest in the problems of rural communities. He was always developing ideas from his Warm Springs experience that could be applied at a national level.

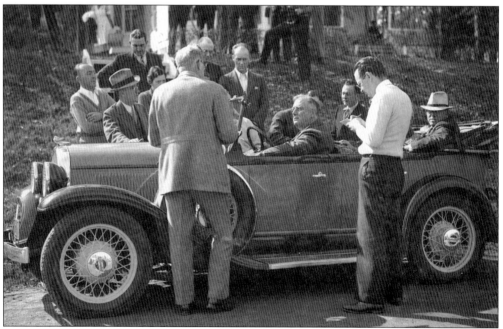

Never before had a president of the United States sat in a car in the middle of nowhere and called a press conference. Before FDR, reporters considered themselves lucky if they could get their prepared questions past the press secretary.

Segregated schools were common in 1930s America. This did not mean that FDR did not care for black students. Eleanor was also deeply concerned that black children receive a quality education. In Warm Springs, a Rosenwald School for African Americans was built, and President Roosevelt took pleasure in dedicating the facility, named for Eleanor Roosevelt, in 1936.

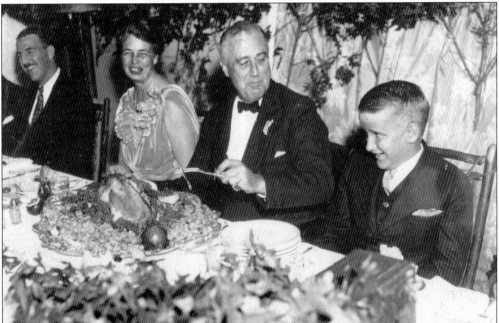

As often as he could, President Roosevelt would return to Warm Springs for Thanksgiving with his companions. It was in Warm Springs where he could leave the rigors and pressures of politics behind. This point is illustrated in a letter to a friend and political rival, Al Smith: "If you are not too exhausted why not run down and see me at Warm Springs while I am there—any time except Thanksgiving day and the day before and the day after."

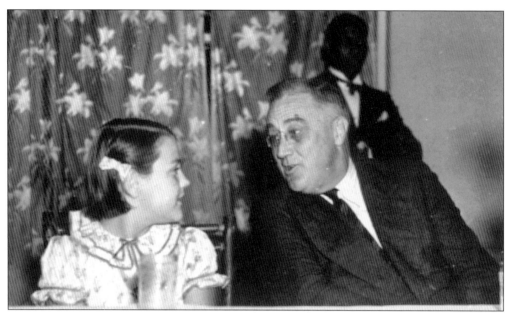

Through the years, Thanksgiving dinners provided FDR an opportunity to greet all of the patients at the institute. "While quite a number of you I have seen before, much to my delight, quite a number I haven't seen before so I am going to stand over by the door, according to Thanksgiving custom, and see you all as I go out. It is fine to be here."

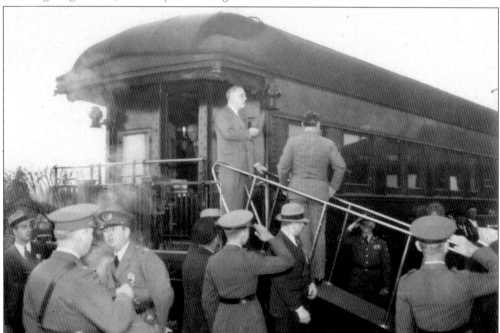

On one of his numerous visits, FDR arrives at the depot with the military presence nearby and greets the villagers of Warm Springs. He loved to comment on all the changes being made in the area. "Every time I come back I see so many new things. Two or three days here this visit won't give me nearly enough time to see all the wonderful things that have happened since last spring."

On one trip, a midnight blue Ford convertible equipped with hand controls was delivered to Warm Springs, and FDR immediately took to the roads of Meriwether County. In this photograph, the authors think Roosevelt is being shown how to operate his new automobile. As a man leans over the seat, FDR is being shown something, and Marvin McIntyre, FDR's secretary, looks on.

Georgia Mustian Wilkins (standing next to FDR), the former owner of Warm Springs, donated the money to build the chapel on campus. FDR was on hand for the dedication. Wilkins also started construction of her summer home on the hillside just above the Little White House. She chose Henry Toombs, who had been so instrumental in designing many of the other foundation buildings, to build it.

With his neighbors gathered around him, FDR dedicated the new community center from his Ford. "I do like to see new buildings, especially if they are as nice looking as this one is. I know my mother is going to be very, very happy when she sees this building. . . . And I also hope you will let her dedicate it instead of my dedicating it. This will be a preliminary dedication."

Although the president of the United States was concerned with affairs of the nation and the world, FDR was proud to be on hand for the dedication of several new facilities in and around Warm Springs. The Sara Delano Roosevelt Community Center, named after FDR's mother, in downtown Warm Springs was one of these.

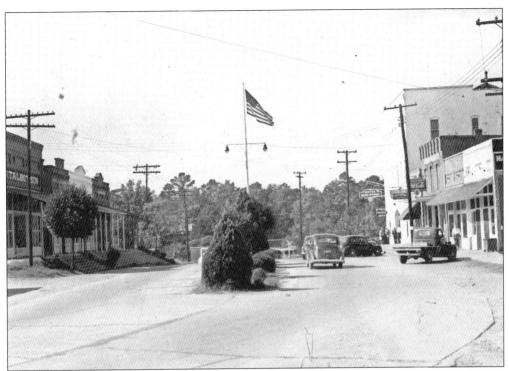

FDR was proud to attend the dedication of the flagpole, once located in the median of Main Street in Warm Springs. The median was later removed after a child was hit and killed by a car when she ran out of the bushes.

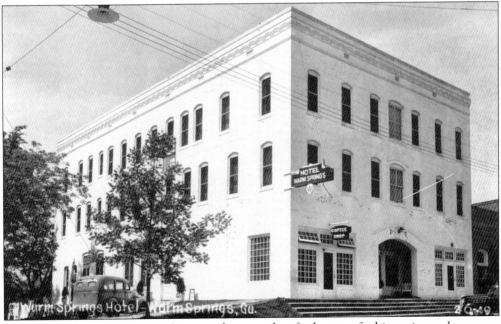

Hotel Warm Springs on Main Street is shown with a fresh coat of white paint and was now an attraction to visitors who were once again arriving in Warm Springs, partly because of the president and partly because of the therapeutic waters still available for public use in the T Pool.

In 1938, FDR traveled to Barnesville, Georgia, to dedicate the REA project. Because his first electric bill in the Little White House was four times higher than that of his Hyde Park estate, it put his mind to work exploring ways to provide affordable power to every American. The Rural Electrification Administration was one of the most popular New Deal programs of FDR's administrations, along with the CCC.

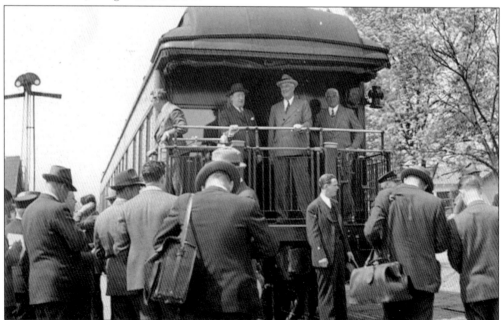

As the world was racing to war, the president's trips to Warm Springs became less frequent. When he did arrive, a walking ramp was placed next to the train and led down to his car nearby, and soon he would be on his way to the foundation, the Knob, or the Little White House.

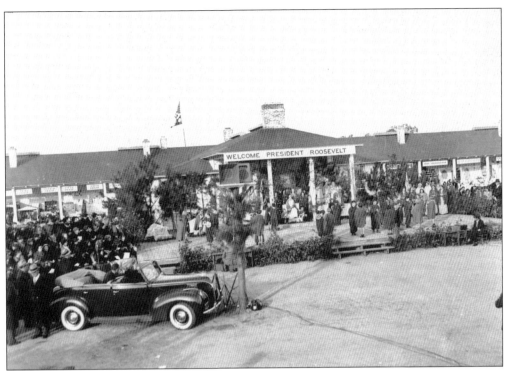

On many occasions, he drove to the Pine Mountain Valley Project to check on its progress as one of his favorite New Deal programs. Located beneath Dowdell's Knob, this program was of the Resettlement Administration. Its purpose was to offer families on welfare in cities the opportunity to own a farm provided they work it and produce income to pay it off.

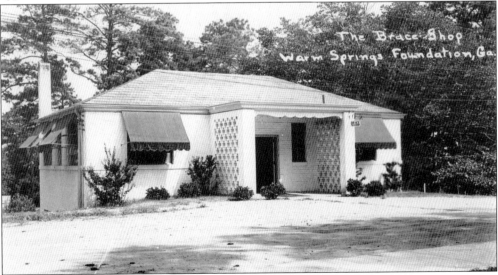

When Roosevelt incorporated the March of Dimes in 1938, most of the funds were earmarked for the areas in which it was collected to benefit the afflicted in their own communities. Other funds were directed toward research, and a portion of the money was given to the Warm Springs Foundation. This source of income enabled the building of new brick facilities, including the Brace Shop that replaced the wooden building.

The Foundation School, built and dedicated by FDR in 1939, was needed to accommodate the growing number of children seeking therapy in Warm Springs. The time spent away from home meant that education was put on hold. This was not the case, however, in Warm Springs. Today the building houses the training and educational staff at the Roosevelt Institute.

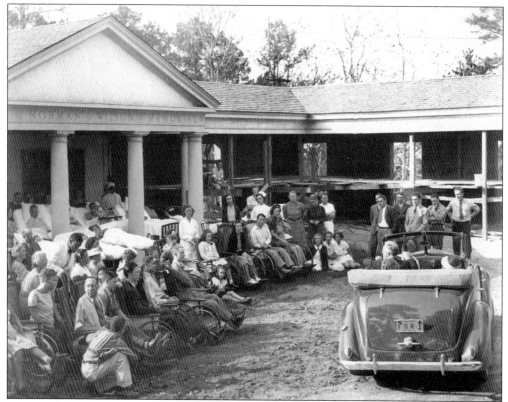

President Roosevelt pulled up before the patients of the foundation and dedicated the new Norman Wilson Infirmary as part of the medical wing on Campus.

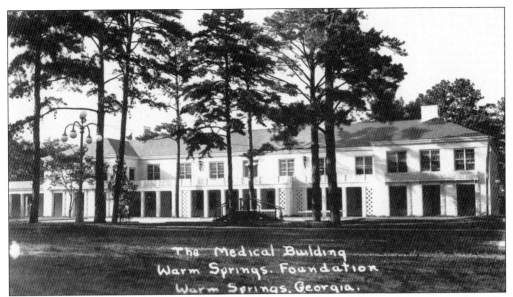

The North Wing of the foundation is where the hospital is located. It is a three-story orthopedic surgical facility. The Walking Court, located in the foreground, replaced the homemade ramps of the past. This facility, dedicated along with the Norman Wilson Infirmary, served as a meeting place where patients could play games of shuffleboard in the open courtyard surrounded by pines.

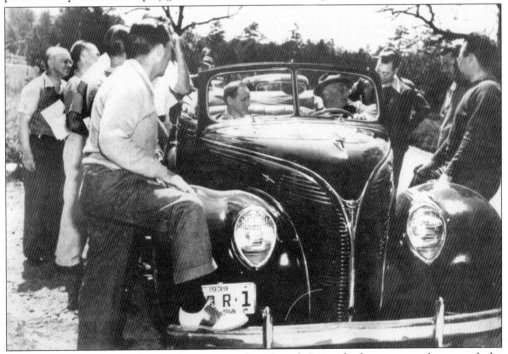

The 1930s closed with the world at war. The United States had not entered yet, and the president's visits to Warm Springs often became delayed or postponed for months as the situation darkened. He expressed his concerns of danger in 1940 during a brief Thanksgiving visit: "I hope to be down here, without any question, if the world survives, next March for my usual two weeks in the spring."

On November 29, 1941, FDR visited his companions in Warm Springs. "This ought to be a good Thanksgiving, especially this year. Because we . . . are in a very unique position today. We are one of the largest nations in the world, and nearly all of the very large nations are either involved at the present time in a war of some kind, a war of self-defense or a war of conquest." He quickly left after negotiations with Japan deteriorated.

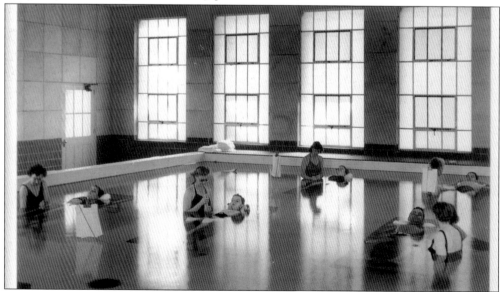

Although President Roosevelt did not visit Warm Springs often during World War II, he was fully aware of the foundation's progress. The spring water that had been used for centuries as a source of healing was now being pumped up to the new indoor pool located on Campus. It was far easier to pump water than transport patients to and from the original pools. Foundation staff and patients' family members were allowed to use the Edsel Ford pool.

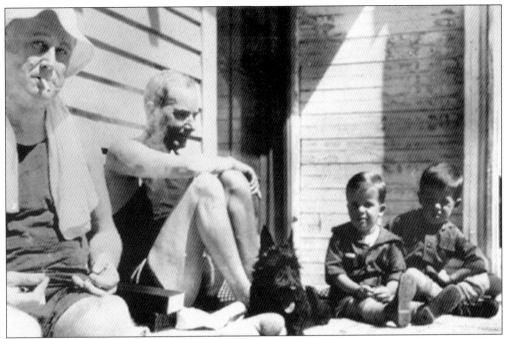

FDR did make a brief stop in the spring of 1943 to swim the springs, soak in some Georgia sunshine, and capture the spirit he had come to rely upon for nearly 20 years—the Spirit of Warm Springs. The president's dog, a Scottish terrier named Fala, who had become his constant companion would often accompany Roosevelt on his travels nationwide, as seen at the poolside in Warm Springs.

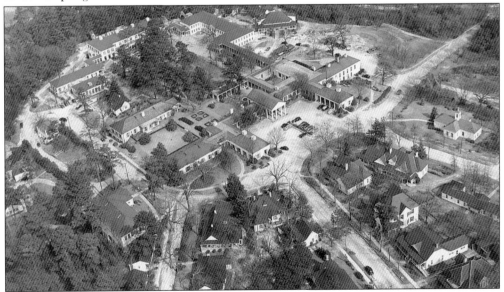

The Georgia Warm Springs Foundation, as seen from the air, shines like a jewel among the green pines. Where the rich had once sought relief from the cities had become a place where people sought and received relief from aftereffects of infantile paralysis. When FDR first arrived, there was nothing but an old hotel and some rundown cottages. Twenty years later, the transformation was nearly complete.

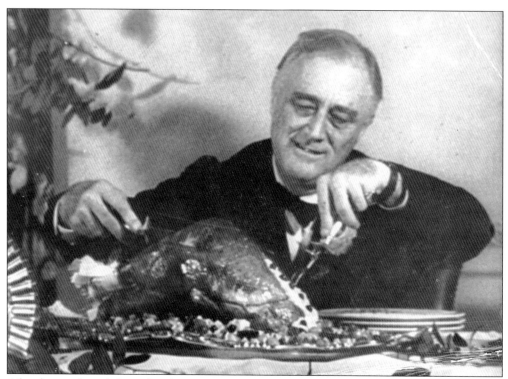

After being elected for a fourth consecutive term, President Franklin D. Roosevelt returned to carve the Thanksgiving Day turkey with his companions in 1944. This was to be the last Thanksgiving that the founder would spend in Warm Springs. He spent the evening reminiscing of the early days. After dinner, the patients performed a skit, "The Spirit of Warm Springs," and he closed the evening by standing at the door and shaking the hands of every patient as they exited.

PRESIDENT HAS HAPPIEST TIMES AT WARM SPRINGS

To reporters who see him regularly through the year, President Roosevelt seems happier at Warm Springs than anywhere else, even Hyde Park. There he, a man who loves to be liked, is among the people who like him best in the world.

When Roosevelt left for Washington to concentrate on the war, the press printed what the people of Warm Springs knew. He looked forward to his return visit in the spring of 1945.

Eight

April 12, 1945
The World Focuses on Warm Springs

He was the only President I ever knew.

—The common sentiment expressed by a generation of Americans who had known FDR as their president

The war in Europe was drawing to a close, the Pacific campaign was raging in Okinawa, Roosevelt was preparing to open the first United Nations conference, and he was having his portrait painted. This painting has been left unfinished.

On April 12, 1945, FDR was planning to attend a barbeque given by the mayor of Warm Springs. Naval musician Graham Jackson brought his accordion to entertain the president that evening. At the foundation, the children were practicing for a skit to present to their benefactor the next day. In the Little White House, FDR was sitting at his card table with his cousins nearby. His friend Lucy Rutherford had brought an artist, Elizabeth Shoumatoff, to paint a life-size watercolor of FDR. Fala, Roosevelt's Scottish terrier, was near his master's side. The sky was springtime blue, and the azaleas and dogwoods were in full bloom. The future seemed brighter. FDR penned some words, finalizing his Jefferson Day Address for the UN Conference that read, "The only limit to our realization of tomorrow will be our doubts of today. Let us move forward with strong and active faith." Shortly after that, he complained of a headache and collapsed. The artist and Lucy immediately left, with her painting unfinished. The president was carried to his bedroom, and at 3:35 p.m., Franklin D. Roosevelt passed away. Overnight, thousands of soldiers from Fort Benning arrived to bid their commander in chief farewell. As the procession left the Little White House, Eleanor held the tradition of saying goodbye to the patients before leaving. The streets of Warm Springs were lined with soldiers and townspeople who wept. The tracks were lined with people from Warm Springs to Washington who wept. Millions across the globe joined those in Warm Springs, Georgia, and wept. Just like the first time FDR arrived in Warm Springs at the depot, he was carried. Now he was being carried again, to leave Warm Springs for the last time. On his first visit, there was little fanfare. On his last exit, the whole world was focused on Warm Springs.

This is the unfinished portrait of President Roosevelt. As the artist completed her brush strokes around the head, FDR suffered a cerebral hemorrhage, and a short time later, he passed away. The original painting is on display in the Franklin D. Roosevelt Memorial Museum in Warm Springs.

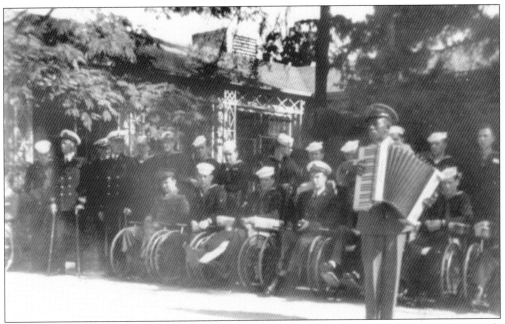

As the president's body was transported to the depot for the train to Washington, thousands of soldiers arrived in Warm Springs to honor their fallen commander in chief. Hundreds of reporters recorded this momentous event as Graham Jackson played "Going Home" on his accordion at Georgia Hall. Soldiers who contracted polio in World War II were sent to Warm Springs for the special care that was offered.

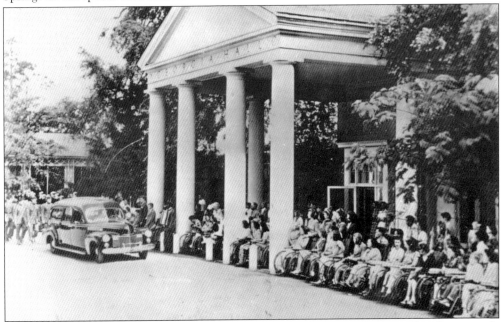

When Roosevelt arrived in and departed from Warm Springs, the patients lined up outside Georgia Hall, and FDR acknowledged each one. It became a tradition. Eleanor Roosevelt honored her husband's tradition by having the procession drive past Georgia Hall so the patients could say their last goodbyes to the president, more fondly known as Doc or Rosey or the Founder.

With the nation at war in Europe and the Pacific, word of the president's passing had to be dispatched quickly. As President Truman moved into the White House, the procession of soldiers that stretched from the foundation into downtown Warm Springs was preparing to transport the only president many of the soldiers had ever known to Washington.

Surrounded by Honor Guard, the hearse pulled into town. This was unlike any scene ever played out in the colorful history of Warm Springs, Georgia. No one would have ever imagined that a president would visit there, much less live and die in this little village. Camera shutters clicking, sobbing, and the soft sound of marching footsteps were the only sounds to be heard in Warm Springs on April 13, 1945.

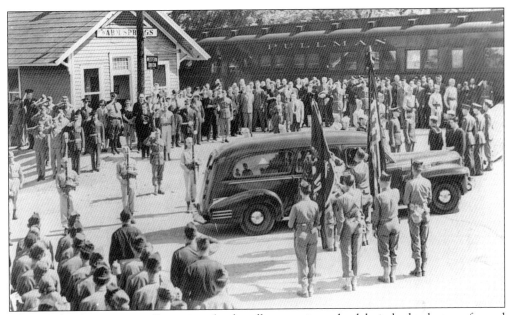

The president's train, specially equipped to handle a man in a wheelchair, had to be transformed into a car that could now carry a coffin. A huge ramp was constructed for the soldier pallbearers to place the coffin through the window into the train.

Fala, the famous Scotch terrier of Franklin Roosevelt's, is led by leash to the train carrying his master's body to Washington. Do dogs know when something terrible happens? This photograph captured the expression of Fala, who looks overwhelmed with the commotion, in the depot.

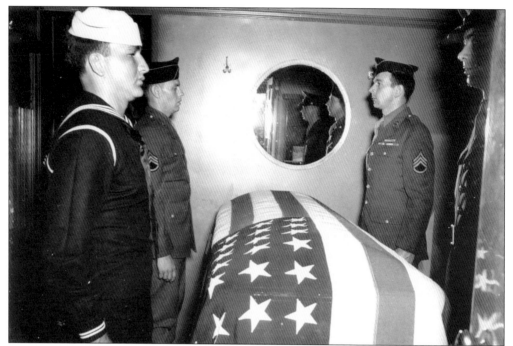

Sentries are posted in honor of their commander in chief for the ride back to Washington. Along the train route, movie cameras recorded the solemn sight as the train passed slowly through communities, allowing the thousands of citizens a chance to see the casket on board. The newsreels were played in theaters across the country over the next few days.

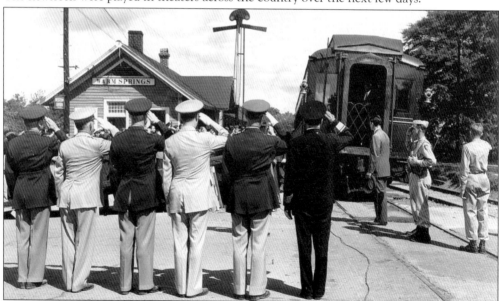

Representatives of the military salute their fallen leader as the train slowly pulls away. Franklin Roosevelt was now leaving Warm Springs for the last time. Eleanor Roosevelt sat alone, watching the throngs of mourners who lined the tracks. She commented that she felt sorrier for the people of the nation than she did for herself and her family. She now realized how important FDR was to Warm Springs, the nation, and the world.

Nine

THE WATERS OF WARM SPRINGS STILL FLOW

*Since no one knows how long this marvelous spring has bubbled,
it is not wild fancy if we guess and say, it has always been.*

—Fred Botts

The *New York Times* eulogized Roosevelt this way: "Men will thank God on their knees a hundred years from now that Franklin D. Roosevelt was in the White House." Almost immediately, Warm Springs became a footnote in history. For two decades, the presence of FDR in Warm Springs had been a powerful force. Now there was a vacuum. It would take years to recover from the shock of FDR leaving so suddenly.

Quietly Warm Springs had touched every American. New Deal programs and policies had developed in Warm Springs such as the REA and TVA. When he saw Southern banks closing, his thoughts developed into the FDIC. Agricultural practices tried on FDR's farm had grown into nationwide policies aimed at benefiting farmers nationwide. FDR's experiences in Warm Springs helped to shape his thoughts both politically and philosophically.

In Warm Springs, Roosevelt dreamed of ending polio, creating a national playground, and developing a modern hydro-therapeutic center. Humbly Warm Springs has also touched nearly every person on earth. To this day, everyone that has taken the polio vaccine can be thankful that Roosevelt contracted polio. What began as a birthday party in 1933 grew to become the March of Dimes that funded research into vaccines. On April 12, 1955, the Salk vaccine was pronounced "Safe and effective." Visitors began returning to Warm Springs to see the "Unfinished Portrait," the Little White House, and Memorial Museum. The foundation, now on the National Historic Register, evolved into the Roosevelt Warm Springs Institute for Rehabilitation, devoted to serving those in need. The village of Warm Springs revitalized itself to become a destination for hundreds of thousands of visitors a year. FDR's farm on Pine Mountain has become part of the F. D. Roosevelt State Park, the largest in Georgia, with campgrounds, hiking, and scenic overlooks. Roosevelt's dream is coming true.

Meanwhile, the waters of Warm Springs will continue to flow, as they have for millennia, touching lives and aiding those who use its remarkable qualities.

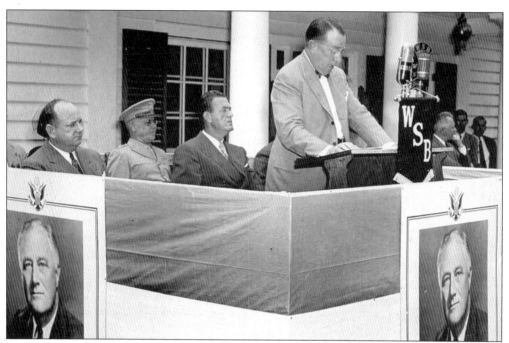

Basil O'Connor tried his best to make Thanksgiving Day in 1945 a joyous occasion, but he could not fill Roosevelt's shoes. The children were thankful without a doubt, but the missing presence of the founder was nearly too much to bear. No longer would there be the long stories, speeches, and skits that the patients looked forward to. Everyone had to learn to adjust to life without Roosevelt.

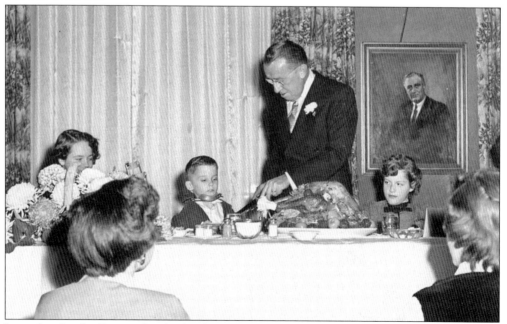

Immediately after Roosevelt's death, the nation called for a shrine in honor of America's only four-time elected President. What better place than the Little White House, many asked. In 1947, Basil O'Connor formally dedicated the cottage, and it opened to the public in 1948.

Commemorative ceremonies were held in Warm Springs every April 12 as people gathered at the depot to remember and honor their former neighbor, Franklin Roosevelt. This was the location where he had first arrived, where he had accepted the nomination for governor, and where he was most often seen by townspeople. As visitation at the Little White House grew, the annual ceremony was moved to the historic site overseen by the Warm Springs Memorial Commission.

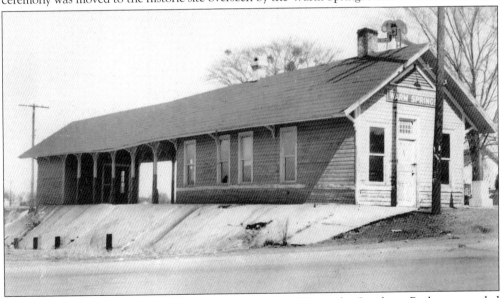

The old depot fell into a state of disrepair during the 1950s as the Southern Railway canceled stops in Warm Springs. There was not enough demand to warrant the additional stop. The depot was bulldozed over, and an empty spot remained, much like the empty feeling people had when they recalled the busy years.

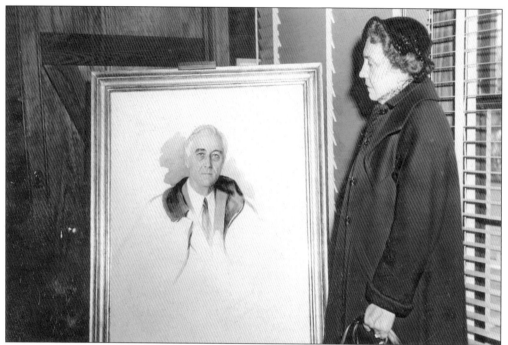

Madame Shoumatoff had kept her "Unfinished Portrait" after FDR died. She printed and sold copies during the 1940s, and in 1952, she sold the painting to the Warm Springs Memorial Commission for a very large sum of money. She is shown here in the Little White House with her painting, as it became a permanent exhibit.

In 1954, a new rehabilitation center, theater, and auditorium, Roosevelt Hall, was dedicated at Georgia Warm Springs Foundation with partial funding from the National Foundation for Infantile Paralysis.

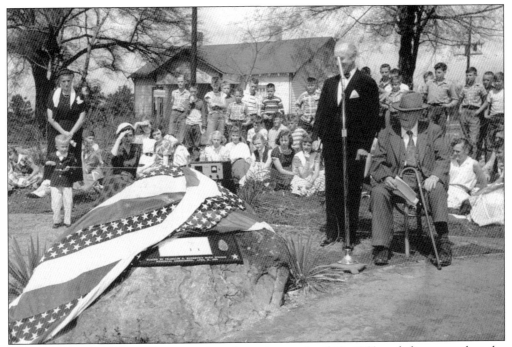

The townspeople of Warm Springs gathered together on April 12, 1955, to dedicate a park at the site of the old depot. That same day, the Salk polio vaccine, funded by the March of Dimes, which was founded by Franklin Roosevelt, became a reality. Charles Palmer, chairman of the Warm Springs Memorial Commission, is shown at the microphone speaking to the townspeople.

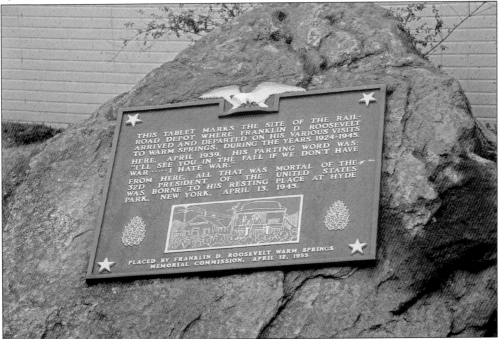

The Memorial Commission funded the stone monument and tablet marking the spot where Roosevelt had arrived and departed during his visits to Warm Springs.

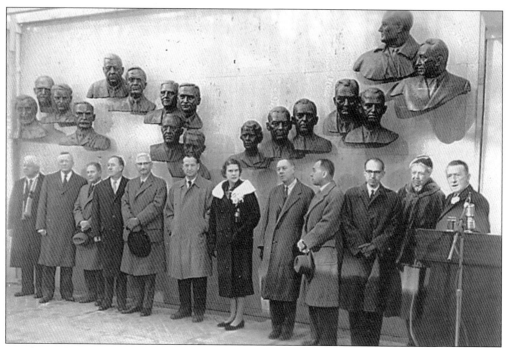

On the 20th anniversary of the founding of the March of Dimes in 1958, the Polio Hall of Fame was dedicated at Founders Hall on Campus at the foundation. Present in attendance were the pioneers who were searching for a vaccine to cure or prevent the virus. Bronze busts of scientists were sculpted by Edwin Amateis and placed on the wall. Eleanor Roosevelt represented her husband. Also pictured are Jonas Salk and Albert Sabin.

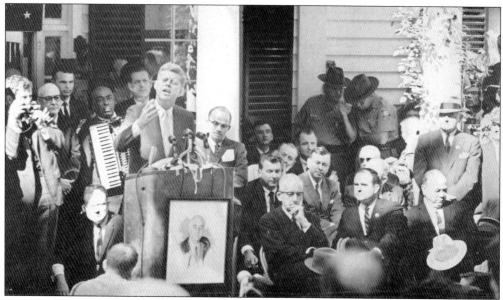

In 1960, Sen. John F. Kennedy needed the Southern vote. He was a Catholic Yankee from Massachusetts in the heart of Dixie. How do you get the vote? Come to Warm Springs, invoke the memory of Franklin D. Roosevelt, and ask for it. He got it, and one month later, he was elected president.

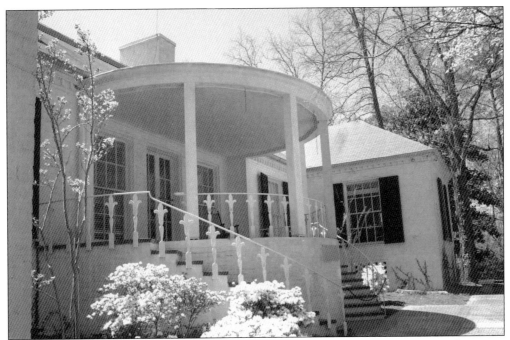

April 12, 1961, is the date that Uri Gagarin became the first person to fly in space. That event overshadowed the opening of the Franklin D. Roosevelt Memorial Museum in Warm Springs. The cottage, known as Mustian Place, was given as a gift to be used as a museum and was once the home of Georgia Wilkins, who was a previous owner of the Warm Springs Resort.

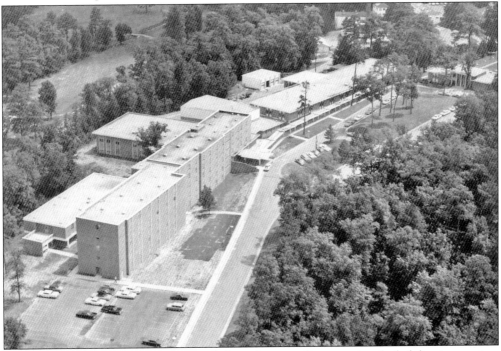

The Georgia Rehabilitation Center was dedicated to providing vocational rehabilitation services to disabled Georgians.

The old golf course, designed by Donald Ross, is named the Roosevelt Memorial Golf Course.

The year 1980 ushered in a new era as Gov. George Busbee announced the new mission for the Roosevelt Warm Springs Institute for Rehabilitation. Today the facility specializes in brain injury care, spinal cord injury, stroke, orthopedic, and general rehabilitation services. The institute also became listed as a National Historic Landmark in the Warm Springs Historic District. The bronze plaque is placed on the flagpole base near Georgia Hall.

Former president Jimmy Carter, pictured here in 1995, receives the Roosevelt Four Freedoms Award by then president Bill Clinton. Seated next to Mr. Clinton is Anna Roosevelt, daughter of James Roosevelt. In 1976, Gov. Jimmy Carter sought the vote of America by announcing his candidacy for president at the Little White House. Everyone who has ever campaigned in Warm Springs, so far, has won.

New expansions and therapy facilities like the Center for Therapeutic Rehabilitation and Camp Dream (pictured here) became realities during the 1990s. The institute now hosts championship wheelchair sports activities of international caliber, like Blaze Sports for wheelchair athletes. What was once Camp Roosevelt for U.S. Marines now plays host for retreats, conferences, and recreational activities for the disabled. These facilities include fishing, swimming, and a fully accessible nature trail that winds through acres of woods.

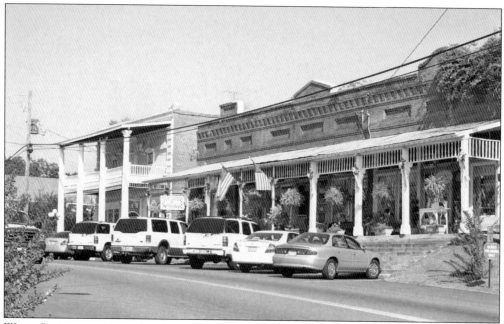

Warm Springs experienced revitalization during the 1960s when Paul Bolstein purchased much of Warm Springs. He undertook the task of restoring many buildings, including the Victorian Tea Room. He also developed the courtyard and shops. Later in 1983, Jean Kidd purchased many of the restored buildings, continuing the development of a tourist attraction. By the 1990s, the village had grown to over 70 specialty shops and restaurants.

In 2001, on the site where the old railway depot had been, the new FDR/Warm Springs Welcome Center was dedicated. It was designed with many features of the original depot, including the high ceilings and hardwood floors. It now serves the village of Warm Springs and all of Meriwether County. Hundreds of thousands of visitors pass through its doors annually seeking information, travel brochures, and maps to local attractions.

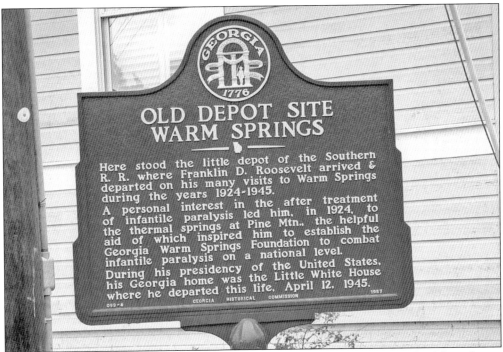

The state of Georgia placed this historic marker on the site of the old depot outside of the welcome center. It tells the story of the depot and its importance in the history of Warm Springs.

The Victorian-era residence of Benjamin F. Bulloch is now home to the world-famous Bulloch House Restaurant. Visitors from all points will find themselves steeped in Southern hospitality as they fill their plates with fried green tomatoes and down-home country cooking. Get there early and be prepared to stand in line at this local favorite. A visit to the gift shop next door is recommended while waiting.

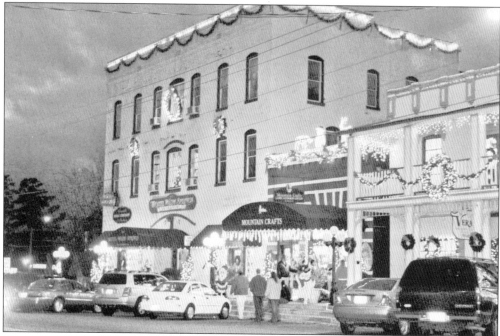

The town slogan, "Take A Step Back In Time," invites people of all ages to experience the charm of this quaint village. After a full day, visitors can retire in one of the local hotels. Shown in this photograph, the Historic Hotel Warm Springs Bed and Breakfast is decked with lights for the Christmas season. It has been completely restored to its 1920s-era state. From the Spring Fling to the candlelight tours, there are events sure to please everyone throughout the year.

In 2004, the Georgia Department of Natural Resources opened the new FDR Memorial Museum. This facility highlights Roosevelt's experiences in Warm Springs through many exhibits and stands as a testament to the man *Time Magazine* called "the foremost statesman and political leader" of the 20th century. It was the warm springs that brought Franklin Roosevelt to Georgia. They flowed into his life and shaped his future along with the town of Warm Springs. They continue to flow today, as they always have.